Christof Thoenes

RAPHAEL

1483–1520

TASCHEN

HONG KONG KÖLN LONDON LOS ANGELES MADRID PARIS TOKYO

© 2007 TASCHEN GmbH
Hohenzollernring 53, D–50672 Köln
www.taschen.com
Translation from German by Karen Williams
Project coordination: Petra Lamers-Schütze
Layout and editorial coordination: Daniela Kumor, Cologne
Cover design: Claudia Frey, Cologne

Printed in Germany
ISBN 978–3–8228–2203–6

Contents

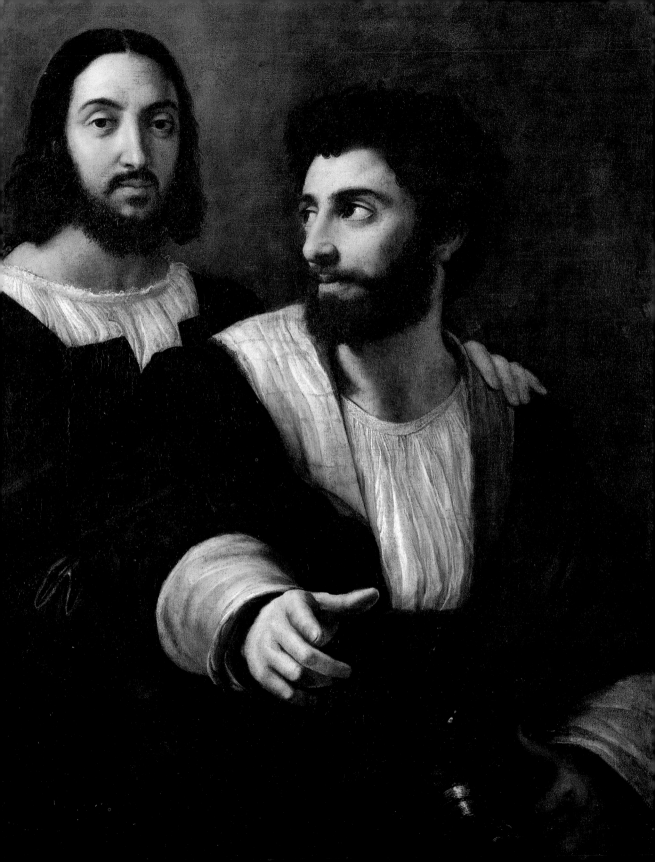

Paths of access to a classic

When Charles Darwin reached the west coast of South America on his circumnavigation of the globe between 1831 und 1836, he came face to face for the first time with true savages, the natives of Tierra del Fuego. Shocked by their appearance and behaviour, he called to mind the paintings of Raphael: the comparison demonstrated for him the scope embraced by the species *homo sapiens*. This is the view of Raphael as the Renaissance classic, a painter who – like Polycletus and Phidias in classical antiquity – laid down once and for all what the human figure should look like. In his definition, beauty and normality are one: it was this that established Raphael's fame and at the same time provoked resistance. For the normal, repeated through the centuries, eventually becomes boring, and indeed burdensome.

But even clichées must first be invented, and it is in this role that we should see Raphael. Over the two decades of artistic activity granted to him, he demonstrated a versatility little short of that of a Picasso. Each task with which he found himself confronted only served to stimulate his powers of invention; in every genre of his art, he discovered new means of expression which pushed back the boundaries of pictorial representation. Few painters before or after Raphael have contributed so much to the enrichment of what we might call the visual colloquialisms of our civilization. He formulated gestures, facial expressions, poses and movements that would be cited by generations to come, and gave shape to relationships between people, to historical situations and to the appearance of the Divine. It is not inappropriate in this context to think of Shakespeare, and all we owe him in terms of understanding human nature. However different their lives may have been, they have exerted the same enduring influence upon our perception of the world.

Inseparable from the concept of the "classic" is that of the "idea". Theoreticians of art even in Raphael's own day were claiming that the artist held in his mind's eye a *certa idea*, to which he strove to do justice in his painting. This interpretation of Raphael's art in terms of a Platonic ideal was developed further by Italian and French theoreticians in the 17th and 18th centuries and can be found in Raphael scholarship even today. According to this school of thought, the true creative act (the *inventio*) took place solely inside Raphael's head; in Lessing's paradox, Raphael would still have been "the greatest genius painting has ever known even if he had been unfortunate enough to have been born

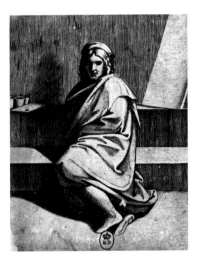

Marcantonio Raimondi
***Portrait of Raphael**, undated*
Copper engraving, 13.6 x 10.6 cm
Paris, Bibliothèque nationale de France,
Département des arts graphiques

Raphael "with no hands": reposing in his studio and swathed in a mantle, the painter seems to be lost in his imagination. The panel is blank, the painting utensils laid to one side.

***Portrait of the Artist with a Friend**, 1519/20*
Oil on canvas, 99 x 83 cm
Paris, Musée du Louvre

Like the double portrait executed for Pietro Bembo in the Galleria Doria Pamphili (p. 86), the painting appears to address itself to a third party who is also one of the company of friends.

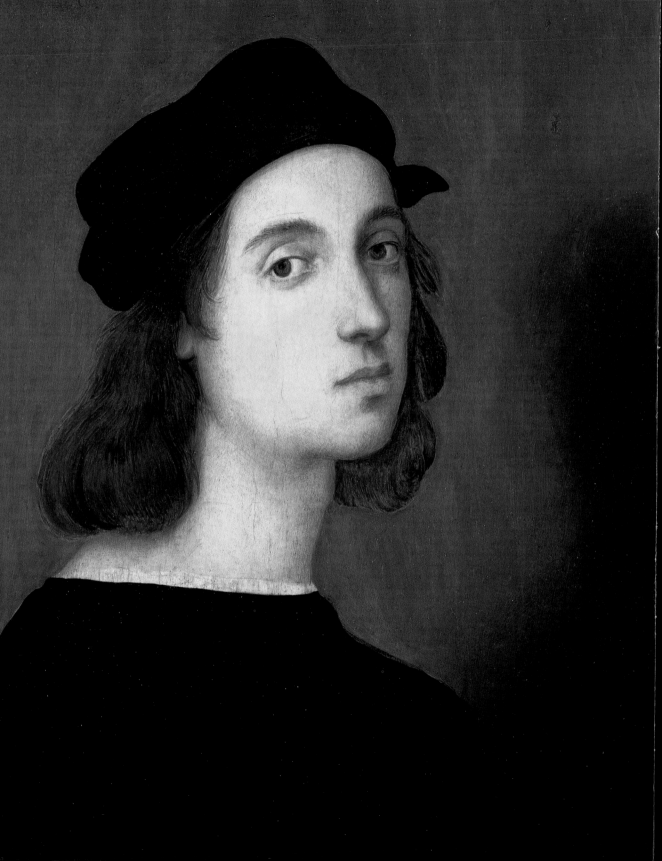

without hands". But access to the world of ideas behind Raphael's paintings is today open only to experts thoroughly versed in the thinking of the theologians and humanists of the day, and it is difficult even for them to establish the true extent of Raphael's role in that sphere. All the more suggestive are the works by his hands. Raphael was (or very soon became) a magician in his handling of form and colour, light and shade, in all the media and techniques he tried out. This can be experienced and – why not? – relished in every encounter with his paintings, frescos and drawings.

Raphael's artistic mastery is that of a realist. His pictures exude realism: they show us people and objects as he saw them and as only he knew how to reproduce them. But they are not, or are only in part, objects from the realms of our own experience. What Raphael was asked to paint were chiefly articles of faith, figures from the Bible and from classical mythology, gods and goddesses, saints, angels, bearers of the message of Christian salvation. This defines the function of his realism: at a critical moment in European thinking, he sets the power of his art against the questionmark being placed over tradition. His subjects are still the old ones, but are rendered plausible with his new style and new means. Heaven is brought into relationship with earth and thereby conveyed to the modern consciousness. Raphael thus became a herald or forerunner of the painting of the Catholic Counter-Reformation, which deliberately sought to speak to the faithful through the faculty of sensual perception. A note of caution, however: Raphael the Catholic, like Raphael the classicist and idealist, is a Raphael judged from a retrospective viewpoint; it is a characterization based on the influence exerted by his œuvre. How did Raphael himself see his role? What did he want? It would appear that Raphael said nothing about his art, or at least put down none of his thoughts on paper. Perhaps he would have done so had he lived longer; the most pertinent statements by Michelangelo and Dürer, for example, date from their latter years. The answers to our questions can therefore be deduced only from his art – from the clues left by his hand in his drawings and paintings.

We have equally little access to his person. His few surviving (and authenticated) letters confine themselves to the discussion of practical matters. Everything that has been written about Raphael the man – a flood of biographical, belletristic and poetic texts – is based not on autobiographical sources but on the impression that Raphael made on his contemporaries. This impression was extraordinary, but it does not tell us what he was like inside. Here, too, our only source is Raphael's work and a series of self-portraits that he executed in various contexts. They depict, strangely enough, not the radiantly handsome heroic type who captures the hearts of all – the Raphael we have come to imagine – but a rather inconspicuous, reserved, almost shy man.

In his Uffizi *Self-portrait* (p. 8), the pupil of Perugino appears at the start of his Florentine period, a modestly-dressed young man just turned 20, a little uncertain in his pose and with fine, slightly melancholy features. In Rome, in his years of glory, Raphael immortalized himself twice as a subsidiary figure in the frescos of the Vatican Stanze, a not uncommon artistic practice in his day. But whereas Signorelli, for example, in his Orvieto *Anti-Christ* fresco (which Raphael knew and had studied), depicts himself large and self-confident at the front edge of the picture, Raphael on both occasions gives us only his head. In *The School of Athens* he perhaps re-used the preliminary drawing that had served for his Uffizi self-portrait; the angle of the head is repeated in mirror image and the face is almost identical (p. 11). He seems to have executed a new drawing for the self-

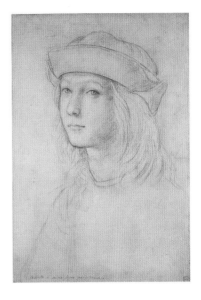

Self-portrait, c. 1500–1502
Black chalk, 38.1 x 26.1 cm
Oxford, Ashmolean Museum. Presented by Body of Subscribers, 1846, P II 515

Inscribed at the bottom edge: Ritratto di se medessimo quando Giovane ("Portrait of himself as a young man").

Self-portrait, c. 1505/06
Oil on panel, 47.5 x 33 cm
Florence, Galleria degli Uffizi

Although the attribution of this poorly preserved panel remains in dispute, in physiognomic terms it corresponds well with Raphael's other self-portraits.

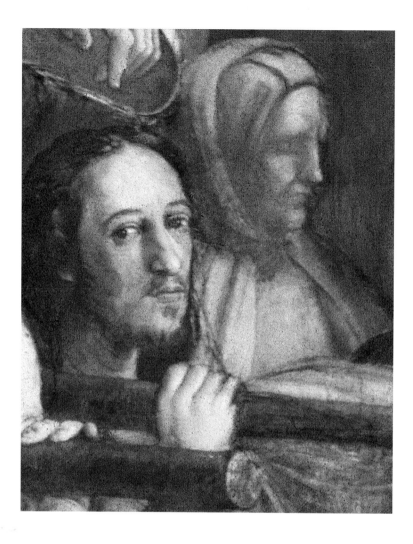

portrait in *The Expulsion of Heliodorus*: it reveals the same slight inclination of the head, but the chin now sports a beard, albeit still somewhat sparse, the features are sharper, the gaze more direct, and the nose elongated almost to the point of caricature (p. 10). Raphael has depicted himself as one of the papal throne-bearers, but here too he remains in the second row, almost disappearing behind the confidently upright figure of the (unidentified) bearer in front. Raphael similarly remains in the background in his last and by far his most impressive self-portrait, the Louvre *Portrait of the Artist with a Friend* (p. 6). The painting probably dates from the final year of his life. We do not know the name of the animated gentleman wearing the dagger in the foreground (although he is certainly not Raphael's fencing master, as he has traditionally been described). Raphael lays a hand on his shoulder and thereby suggests the two are friends: it is a dialogue we are unable to follow. Raphael's somewhat tired look is directed not at the friend but at us, or rather at the mirror standing in front of him as he painted. He does not look happy.

Self-portrait, 1512
Detail from ***The Expulsion of Heliodorus***
(pp. 46–47)

Raphael portrays himself not as an artist but as a member of the papal retinue.

Self-portrait, 1510/11
Detail from ***The School of Athens***
(pp. 40–41)

The semi-shaded head in the foreground is that of Sodoma, who worked in the Stanza della Segnatura prior to Raphael; part of his vault decoration still survives. Signorelli had portrayed himself in a similar fashion in Orvieto, in the company of his predecessor Fra Angelico.

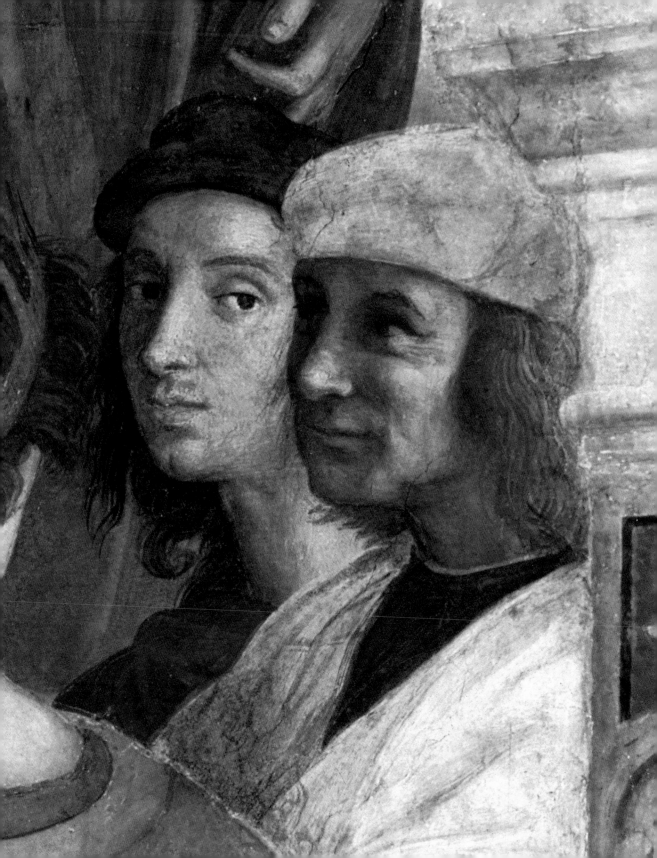

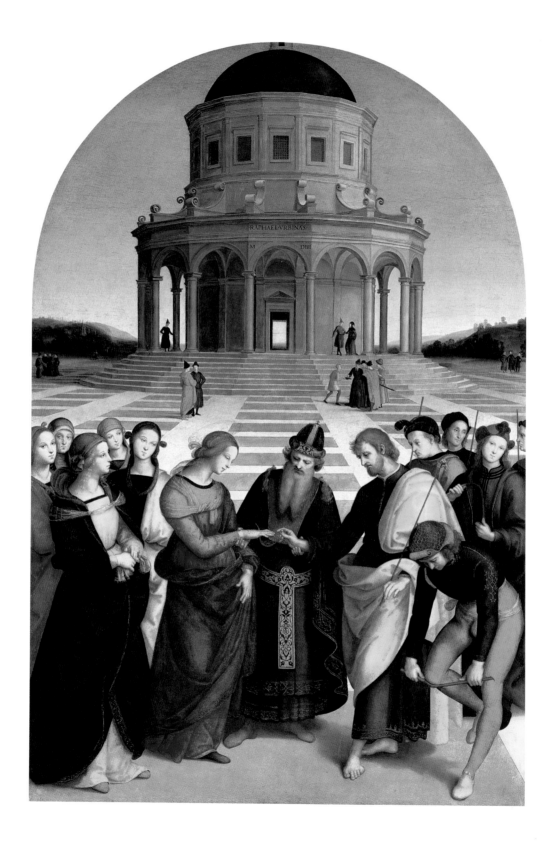

Apprenticeship and early years as a master

Raphael had a good start. At the beginning of his lifetime, Italy still enjoyed a state of relative political equilibrium between large and small city-republics, signorie and territorial princedoms. None of these were what we would call democratic systems and life under them did not unfold peacefully. But the constant warfare between families, factions and local despots failed to impact on the high standard that had been sustained since the Middle Ages in the sphere of literature and the arts. Extraordinary works arose everywhere, and respect for those who created them was enormous. The small duchy of Urbino, where Raphael was born in 1483, was home to one of the most glittering courts of the Renaissance. Raphael's father, Giovanni Santi, was highly regarded in Urbino as a competent painter; although not permanently stabled at the ducal court, he was regularly employed in its service. We know him above all as the author of a rhymed chronicle about Urbino, dedicated to Duke Federico da Montefeltro, in which he reveals himself to be an educated man of letters and a connoisseur of the contemporary art scene. He considers Andrea Mantegna, Giovanni Bellini, Luca Signorelli, Leonardo da Vinci and Pietro Perugino to be the leading masters of his day, but also mentions the great Netherlandish artists Jan van Eyck and Rogier van der Weyden – names that must have rung in the young Raphael's ears.

Raphael's father died in 1494; his mother had already passed away three years earlier. According to Vasari, the great artist biographer and art historian of the 16th century, Giovanni Santi still found time to apprentice his 11-year-old son to Pietro Perugino in Perugia – dreadfully early by our standards, but not unusual in those days. Perugino was almost exactly the same age as Leonardo; for Santi, both artists represented the younger generation. We would no longer place them in the same category today. Leonardo opened up new horizons for his art, whereas Perugino's appeal lay primarily in his creation of "that ethereal mood of inner contemplation, harmony and poise which was incomparably suited to religious painting and which matched to a high degree the taste and spiritual needs of the age" (R. Hiller v. Gärtringen). It was for this reason that, unlike Leonardo, Perugino became highly successful in commercial terms: his circle of customers was constantly expanding and Perugian dealers sold his paintings for large profits.

Perugino's strength lay in his strict rationalization of the creative process. The journey from preliminary design to finished painting was broken down into a

Pietro Perugino
The Marriage of the Virgin, 1500/1504
Oil on panel, 234 x 185 cm
Caen, Musée des Beaux-Arts

The composition that Raphael would subsequently borrow goes back to a solution that Perugino had evolved 20 years earlier for his fresco of the *Donation of the Keys* in the Sistine Chapel.

The Marriage of the Virgin, 1504
Oil on panel, 174 x 121 cm
Milan, Pinacoteca di Brera

Perugino's foreground-background structure gives way in Raphael's composition to an atmospheric space that envelops the figures, architecture and landscape.

God the Father Crowns St Nicholas of Tolentino (fragment), 1500/01
Oil on panel, 112 x 75 cm
Naples, Museo di Capodimonte

The present fragment represents part of an altarpiece that Raphael executed for the Baronci Chapel in S. Agostino, Città di Castello. Raphael concluded the contract jointly with one of his father's assistants, who had taken over the running of Santi's workshop after his death. After being damaged in an earthquake, the altarpiece was dismantled and the individual sections sold.

number of stages, and these were divided between the master and his assistants and apprentices. Motifs, once developed, were re-used in different combinations. Raphael would quickly free himself from his teacher's manner, but the system of preparing a painting by means of compositional sketches, drawings from models, detailed studies, *modelli* (presentation drawings) and ultimately the full-size cartoon and its transfer to the final medium (panel, canvas or plastered wall) was one that he followed all his life. And the workshop that he later ran in Rome was comparable in its efficiency, if not in its artistic results, with that of Perugino.

A Perugino as a teacher, plus the discipline of a large *bottega*: good grounds for a young genius to rebel. There is nothing to suggest that Raphael did so. But if Perugino's style can be felt in all Raphael's early work, it is not his only source: the influence of Signorelli and Pinturicchio, the two other great artists of the region and Perugino's rivals, is also demonstrable in Raphael's earliest surviving paintings and drawings. It is a pattern of behaviour that we will encounter again and again with Raphael: he assimilates what others can do not in order to repeat it, but to go beyond it. He doesn't want to do it differently, he wants to do it better and, through his more profound understanding, arrive in new ways at what his predecessor was trying to achieve. Perhaps this is characteristic of a talent whose career began (seemingly) without problem. A comparable example might be Mozart, of whom it has been said that his innovations "nestled themselves smoothly into convention without pathos, drama or protest; they appeared less as acts of daring than as the wonderful revelation of possibilities that remained closed to lesser minds" (Ernst Křenek).

Raphael also appears to have taken the step into financial independence without noteworthy conflict. The 16 or 17-year-old received his first commissions not in Perugia – where the Perugino workshop had a firm grip on the market – but in neighbouring Città di Castello. A *Processional banner* (p. 15) with the Holy Trinity on one side and the creation of Eve on the other, probably commissioned in connection with an outbreak of the plague there in 1499, is today recognized almost unanimously as the work of Raphael, whereas numerous other, very varying pictures believed to document the early development of the young painter are the subject of dispute. It was as a magister – master – that Raphael signed the contract for a large altarpiece, or *pala*, for S. Agostino in Città di Castello, dedicated to St Nicholas of Tolentino and today surviving only in fragments (p. 14).

Lo sposalizio (p. 12), the betrothal of the Virgin to Joseph, was also painted for Città di Castello. Holy relics such as the Virgin's wedding ring in Perugia cathedral and her girdle in Prato enjoyed particular veneration, as they represented the earthly remains of the Mother of God, who was assumed into heaven in her physical body. Perugino had already treated the Marriage of the Virgin in an altarpiece commissioned in 1499 for the Chapel of the Virgin in Perugia (p. 13), and it seems that Raphael was to produce something like a replica. He retained Perugino's rigorously symmetrical composition and slightly troubled faces, but the Virgin and her groom are grouped in a considerably looser fashion and the high priest, who is bringing together the hands of the bridal couple for the exchange of the ring, holds at least his head at a slight angle. And it is only in Raphael's painting that the Temple of Solomon (before which, according to *The Golden Legend*, the scene takes place) truly radiates the majestic solemnity that infuses the atmosphere of the picture. Resplendent in large lettering over the entrance is the signature RAPHAEL URBINAS MDIIII. The artist was probably already aware of what the Swiss art historian Jakob Burckhardt observed over 300 years later: Raphael painted as Perugino always should have done.

The *Oddi altarpiece* (p. 16) was the first work in which Raphael appeared in open competition with Perugino's workshop; unmistakably his own, it became his first masterpiece. During those years, two of Perugia's leading families, the Oddi and the Baglioni, were embroiled in a bitter struggle for control of the city; the dispute had cost lives on both sides and the victims were buried in Perugia's Franciscan church. In 1504 Leandra Oddi – a Baglioni by birth – commissioned an altarpiece for the S. Francesco family chapel. It depicts the Assumption and Coronation of the Virgin – a double subject whose elements could be found in various altarpieces by Perugino. The problem lay in the fact that the Assumption of the Virgin (and the Ascension of Christ) usually took place, in Perugino's works, in a mandorla set into the sky. This solution no longer fitted Raphael's concept of pictorial space. Twelve years later, Titian would deploy all the suggestive power of his brush to bring the miraculous event vividly to life. The young Raphael opts for a different solution: the Assumption itself is not shown; the Virgin is already in heaven, receiving her crown, while beneath her the disciples, displaying varying degrees of astonishment (but not grieving, as in older representations of the Death of the Virgin), are gathered around her tomb, out of which lilies and roses are blooming. The miracle of the Assumption can thus only be deduced from the reactions and responses it has prompted on the two levels: a way of making "the invisible visible" (Michael Schwarz) that we shall encounter again in later works by Raphael. The problem of the credibility of miracles is particularly acute in the legend of St Thomas, who refuses to believe the Virgin has been assumed – until her girdle falls from heaven into his hands. He

Processional banner with representation of the Trinity, c. 1499/1500
Oil on canvas, 166 x 94 cm
Città di Castello, Pinacoteca Comunale

The earliest generally acknowledged work by Raphael was used as a processional banner and survives in only poor condition. The reverse, today detached from the front, shows the creation of Eve from Adam's rib.

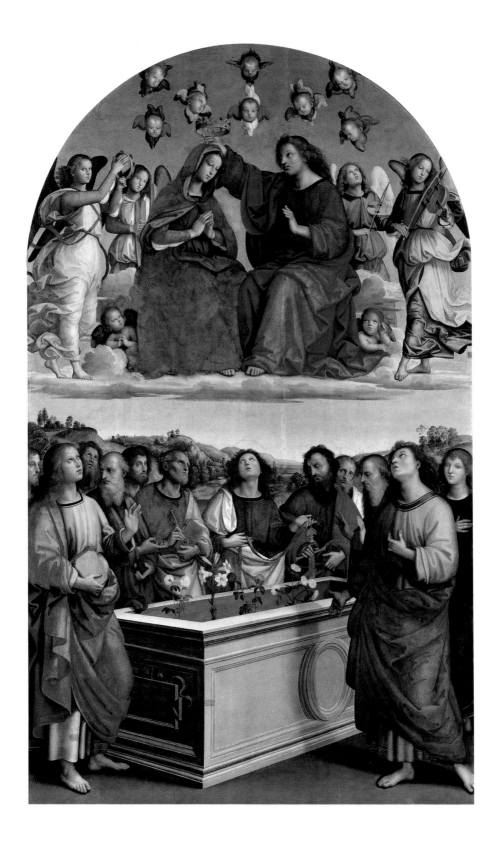

The Knight's Dream, c. 1504
Tempera on wood, 17.1 x 17.1 cm
London, The National Gallery

In the preliminary cartoon, also housed in the National Gallery in London, the goddess on the left looks even more severe, while the one on the right teasingly reveals more flesh. Raphael evidently decided to make their contrast less extreme in the final painting.

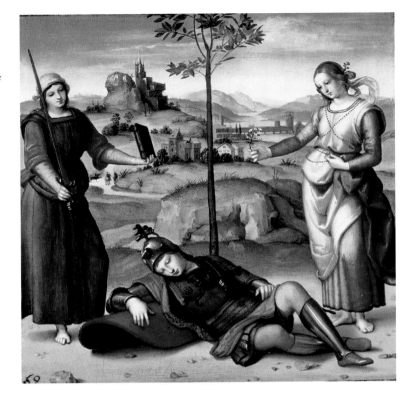

The Three Graces, c. 1504
Oil on panel, 17 x 17 cm
Chantilly, Musée Condé

This small panel forms a diptych with the identically sized *Knight's Dream*. Both paintings belonged to the Borghese collection until 1800, but were then sold separately.

PAGE 16:
Coronation of the Virgin (Oddi altarpiece),
c. 1504
Oil on canvas, transferred from panel,
267 x 163 cm
Rome, Pinacoteca Vaticana

The *Oddi altarpiece* is accompanied by a predella illustrating three episodes from the life of the Virgin: the Annunciation, the Adoration of the Magi and the Presentation in the Temple. This predella is also housed in the Vatican.

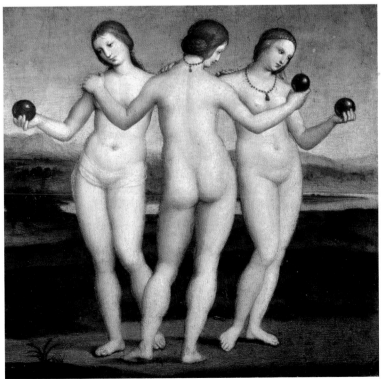

stands here, flanked by St Peter and St Paul, at the centre of the group of disciples, holding the girdle in his hands and gazing upwards in utter amazement.

The contract between the donor and Raphael has not survived, and so we do not know how much of the subject matter was specified from the outset and how much Raphael himself contributed to its formulation. There are good grounds to suspect that the Franciscans, protagonists of Marian theology, also had a say. The stylistic differentiation of the two levels, however, was Raphael's own idea and would have significant bearing upon the future. Thus the celestial sphere is characterized by a hieratic order, pious faces of the same shape and a shallow arrangement of the figures; there is no spatial depth. On the earthly plane the disciples wear more individualized expressions and are grouped with greater variety. They have volume and cast shadows. The diagonal positioning of the tomb reveals Raphael to be a perspective artist who has learned from Piero della Francesca.

Alongside large altarpieces, Raphael also painted numerous small religious scenes intended for domestic use. *St George and the Dragon* (p. 19) depicts an episode from *The Golden Legend,* in which the chivalrous saint liberates the Libyan city of Silena from a dragon requiring an annual human sacrifice. The painting was probably commissioned by Duke Guidobaldo da Montefeltro, who in 1504 was appointed a *capitano della Chiesa* (captain of the Church) by Pope Julius II; the princess kneeling in the right-hand background is wearing a halo, like her liberator, and may be a reference to the Church, which must be protected from the threat of Islam. Knight and horse are dressed as if for a royal tournament, and compared with the monsters of Northern masters, even the dragon is of only moderate hideousness. In its technical perfection, Raphael's tiny picture (it measures just 28 cm high) is fully the equal of the Netherlandish artists so admired in his day. Raphael subsequently painted no further miniatures of this kind, but he never lost the technical skills honed in their execution.

A similar precision of execution characterizes *The Knight's Dream* (p. 17 above) and *The Three Graces* (p. 17 below), a pair of paintings which also date from around 1504 and which measure an even smaller 17 x 17 cm. The knight is Scipio Africanus, to whom as a young man (according to Cicero) Minerva and Venus appeared in a dream. Minerva, dressed in habit-like robes and with her dark hair concealed demurely beneath a headscarf, presents the slumbering knight with a sword and a book. Venus, blond and with her skirts slightly gathered, holds out a flowering spray to him. The alternatives with which he is being presented – a virtuous, military life dedicated to war and study versus an existence devoted sooner to pleasure – are obvious. The background rises on the left to a mountain fortress and slopes down on the right to a scenic river valley, but the laurel tree with its promise of glory stands precisely in the centre. Does it thereby declare that the two ideals can in fact be reconciled, or is Raphael's gentle temperament declining to offer a blunt allegory of choice? His later œuvre, too, not infrequently contains unclear statements that have the iconologists racking their brains. It remains entirely a mystery as to what the three Graces have to do with the knight's dream. Their formal inspiration is without doubt drawn from the antique group of the Three Graces in the Piccolomini Library attached to Siena cathedral. The apples which they are holding in Raphael's painting suggest a reference to the Hesperides, givers of eternal youth. The middle figure originally had both arms placed on the shoulders of her companions, while the right-hand figure covered her pubic area with the gesture of a *Venus pudica*. Only the left-hand figure held an apple. Is she Aphrodite, who awarded the fruit to Paris not because he judged her the most virtuous, but the most beautiful? This, too, must remain speculation.

St George and the Dragon, c. 1504/05
Oil on panel, 28.5 x 21.5 cm
Washington, DC, National Gallery of Art,
Andrew W. Mellon Collection

In 1504 Duke Guidobaldo da Montefeltro, for whom this small panel was probably executed, was made a knight of the Order of the Garter by Henry VII of England. The first four letters of the famous motto "Hony soit qui mal y pense" can be made out on the blue ribbon on St George's jambeau.

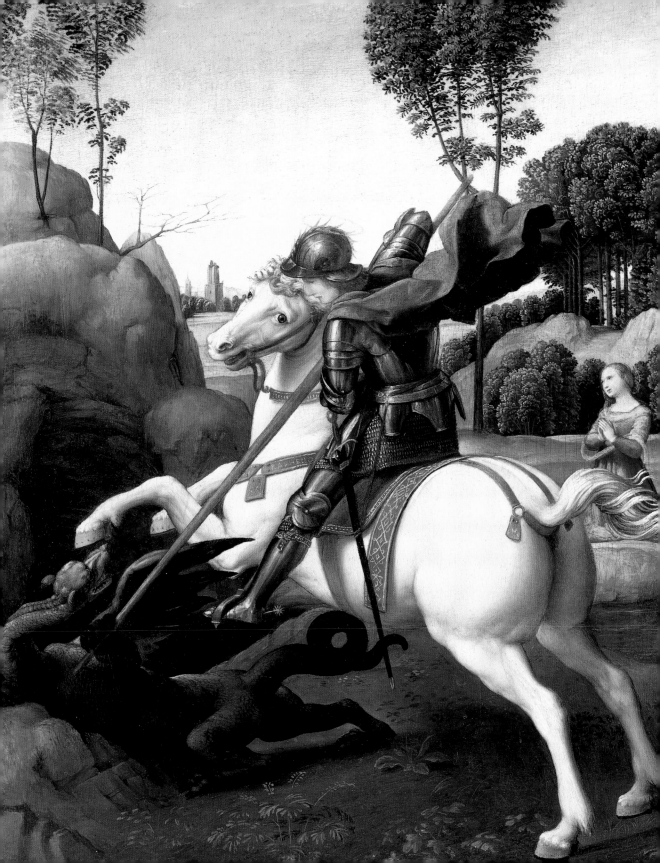

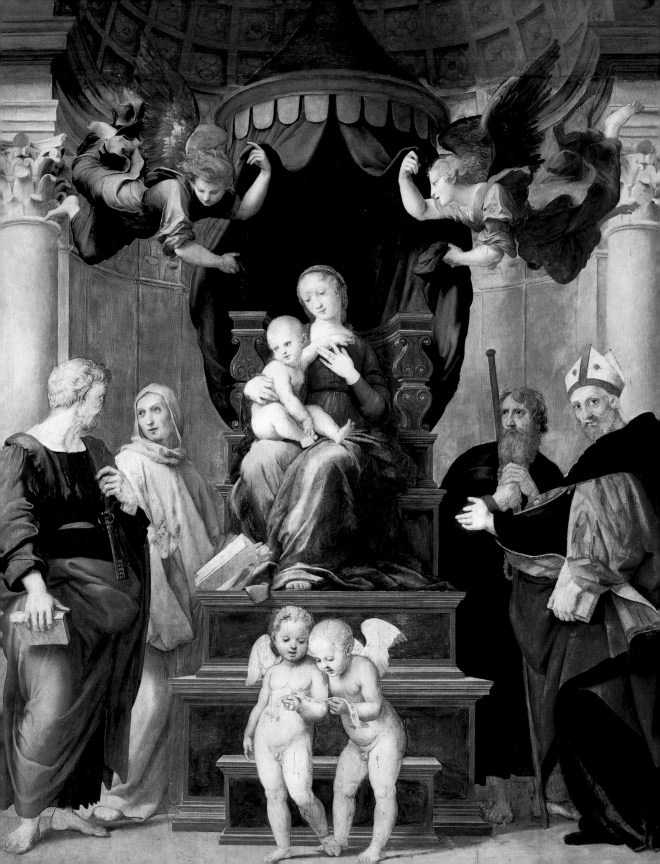

Raphael in Florence

Raphael started learning early and stopped late – or rather never stopped at all, if one follows his later development. Scholarships, which might have secured the student a large degree of independence and self-confidence, did not yet exist, and so Raphael had to start producing, too, at an early stage. The danger lay in the success to which he aspired, and which he indeed achieved, from early on: it could have led him to apply what he had learned all too quickly and to keep on churning out what had proved successful and what he had mastered at the technical level. There was no lack of wealthy clients from the Umbrian cities and from Urbino ducal circles, and Raphael no doubt knew how to court them. But the 20-year-old had set his sights elsewhere.

It must have been clear to Raphael that he was unlikely to succeed in Florence with what he could offer from Perugia. Since the days of Donatello and Ghiberti, Brunelleschi and Alberti, the pace of artistic life on the Arno had been quickened by public competitions and theoretical debates. Leonardo da Vinci, back in the city since 1500, was at the pinnacle of his career; in the large council chamber inside the Palazzo Vecchio, he was working on the cartoon of the *Battle of Anghiari* that was to appear directly alongside the *Battle of Cascina* by his rival Michelangelo Buonarroti, younger by a generation. Fra Bartolomeo had returned to painting after four years in a monastery prompted by the preachings of Savonarola. Donato Bramante, forced to leave Milan at the same time as Leonardo, had gone to Rome, where he studied the antique ruins and built the Tempietto of S. Pietro in Montorio, the Belvedere court in the Vatican, and St Peter's. A new chapter in the history of Italian art had begun, and Raphael demanded a place in it. The effort required would be enormous.

Leonardo and Michelangelo had studied both the anatomy of the human body and the mechanics of its movement, and hence they knew how to think in figures. They built their compositions not from a standard selection of obligatory poses, expressions and gestures but from the action and interaction of living bodies and animated faces. It was through these, so Leonardo believed, that the emotions of the soul were expressed. In his endeavour to learn to speak this new body language, Raphael again proceeded in a synthetic fashion: he copied figures by both Leonardo (p. 21) and Michelangelo (p. 27). He did not throw overboard all that he had previously learned, however: those with a trained eye will find motifs by Pietro Perugino, Luca Signorelli and Filippino Lippi even in his later

Study after Leonardo's **Leda**, c. 1504/1508
Pen over stylus on paper, 30.8 x 19.2 cm
Windsor Castle, The Royal Collection, RL 12759

Leda's complicated, serpentine pose (known only from copies) must have interested Raphael; he would return to it in his *Galatea* (p. 68).

Madonna del Baldacchino, 1506/1508
Oil on panel, 279 x 217 cm
Florence, Galleria Palatina

Raphael returned to the cartoons for the angels hovering on either side of the baldachin when he came to paint the Sibyls in the Chigi Chapel in Santa Maria della Pace (p. 74).

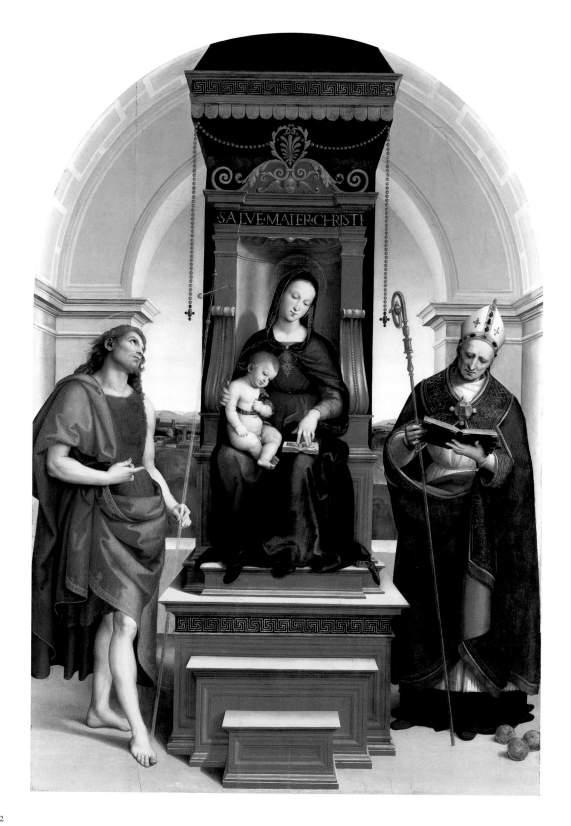

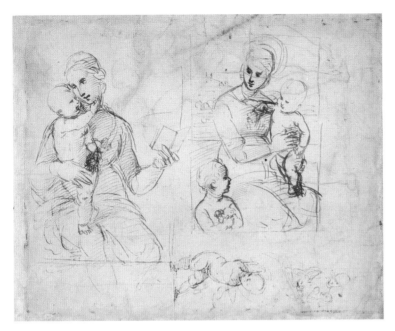

Madonna studies, c. 1506
Pen on paper, 25.2 x 19.7 cm
Vienna, Graphische Sammlung Albertina,
inv. no. 206 r

These sketches cannot be assigned to a specific
Madonna painting; Raphael is varying a theme
that was "in his head".

paintings and frescos. His drawing practice is thereby notably purposeful: it is an exercise not in immersion in the object, but in turning his sketches to account. Within a sheet of studies for a Virgin and Child, for example, he outlines the motif he has in mind with a few strokes of the pen (p. 23). An anatomical study (p. 24 below), meanwhile, rather remains at the level of the physical frame than fathoms the mechanism of physical movement. Raphael is somewhat vague about the finer details of the human skeleton (something Michelangelo, had this sheet fallen into his hands, would have scoffed at with derision).

Of the three large altarpieces that Raphael (probably) completed in Florence, two were destined for Perugia; the third, for a Florentine client, was only commissioned shortly before his departure for Rome. *The Ansidei Madonna* (p. 22) is still governed by the profound meditative stillness of Perugino's altarpieces; the figures make contact neither with each other nor with the viewer, but have nevertheless gained in individuality and truth to life. St John the Baptist, in the left-hand foreground, gazes upwards with rather aimless intensity; his contrapposto is still rather decoratively Umbrian, but both feet stand firmly on the floor and one can sense a body beneath the draperies. The tonal gradation achieved in the draperies illustrates the technical progress that Raphael has made; the realistically modelled St Nicholas, absorbed in his book, is indebted to Signorelli.

The *Baglioni altarpiece* (p. 25) was destined, like the earlier *Oddi altarpiece* (p. 16), for S. Francesco in Perugia. The Baglioni were caught up in a murderous struggle with the Oddi for control of the city, but there were bloody feuds even within the family. In 1500 the young Grifone Baglioni, himself brutal and unscrupulous, was attacked in the middle of the street by one of his cousins; he died, streaming with blood, in the arms of his mother Atalanta. Five or six years later, in memory of her son, she commissioned an altarpiece depicting the Lamentation of Christ.

The Madonna and Child with St John the Baptist and St Nicholas of Bari (*The Ansidei Madonna*), c. 1505
Oil on panel, 247 x 152 cm
London, The National Gallery

Despite its large format, the painting is executed with the precision of a miniature, rendering the Virgin's throne as a work of exquisite joinery. One of the three predella panels for this altarpiece, showing *St John the Baptist Preaching*, still survives and is also housed in the National Gallery.

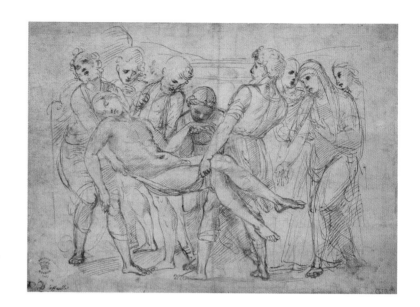

Study for *The Entombment (Baglioni altarpiece)*, c. 1507
Pen and ink on paper, 23 x 31.9 cm
London, The British Museum, 1855-2-14-1

Study for *The Entombment (Baglioni altarpiece)*, c. 1505/06
Pen over black chalk on paper, 30.7 x 20.2 cm
London, The British Museum, 1895-9-15-617

In his treatise on painting, Alberti cites a Roman relief of the dead Meleager as an example of the portrayal of a lifeless body; in the same chapter, he recommends the artist to start from the skeletal structure when drawing the human figure.

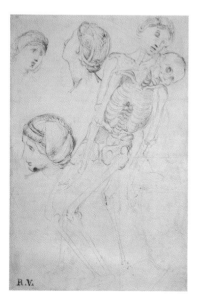

Here was an opportunity to paint a *storia*, the narrative story that Alberti had identified as the painter's proper aim. The number of surviving preliminary drawings, studies and sketches is unusually large (something that had already struck Vasari); they offer an insight into a design process of unexpected complexity. The earliest sheets show a four-figure Lamentation as familiar from the paintings and frescos of Perugino and Signorelli, formulated with the aim of incorporating the widest possible range of grief-stricken poses and expressions. But it does not stay like this: bearers appear to lift up the corpse lying on the ground and, in the final version, to carry it away to the left. The Lamentation has become an Entombment, or more accurately a Bearing Away to the Tomb (*il trasporto di Cristo*). Raphael may have drawn some of his inspiration from Signorelli, and from Mantegna, too, but he may also have looked at a Roman sarcophagus today housed in the Vatican and showing Atlanta lamenting the death of her husband Meleager, killed by his brothers. Alberti had named precisely this scene as an example of a *storia*. As the background to his painting, Raphael creates an expansive, wonderfully detailed panorama, which extends from the mouth of the grave in the left-hand foreground to Calvary visible in the distance. In front stand two figural groups, interwoven as if in relief: on the left, the dead Christ and two bearers, together with John, Nicodemus and Mary Magdalene; on the right the Virgin, who having taken her final leave of her son sinks unconscious to the ground and is caught and held by her three female companions. As in the Oddi *Coronation of the Virgin,* the scene now combines two events, but this time developed horizontally instead of vertically. Such is the throng, however, that the viewer has difficulty in assigning the feet appearing in the bottom foreground to their proper owners. The eye is struck by the athletic young bearer who draws himself up in heroic fashion in the foreground: an idealized portrait of the young Grifone? Unmistakable in the figures here is the overwhelming impact of Michelangelo: the kneeling young woman on the right paraphrases the Virgin in the *Doni Tondo,* Nicodemus the unfinished statue of *St Matthew* (the drawing reproduced as p. 27 is located on the back of a com-

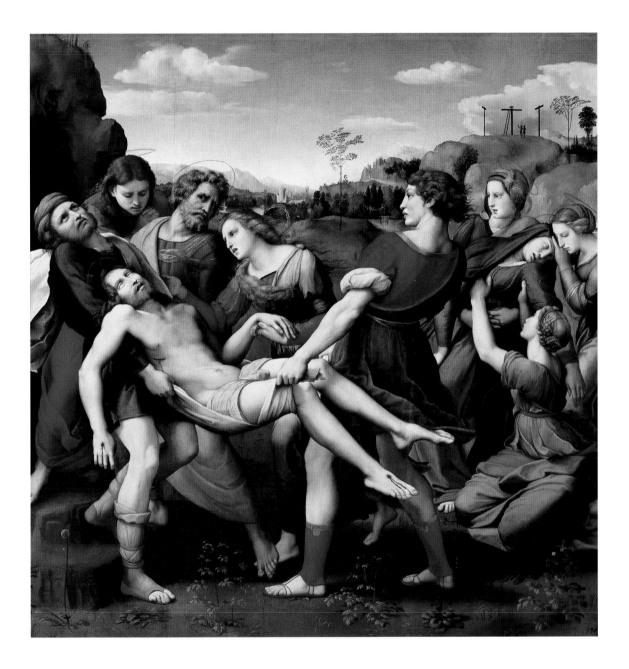

The Entombment (Baglioni altarpiece), 1507
Oil on panel, 184 x 176 cm
Rome, Galleria Borghese

This altarpiece originally incorporated three
predella panels depicting allegories of Faith,
Hope and Charity, today in the Pinacoteca
Vaticana, and a top panel of God the Father in
Blessing, probably executed by an assistant and
today in Perugia.

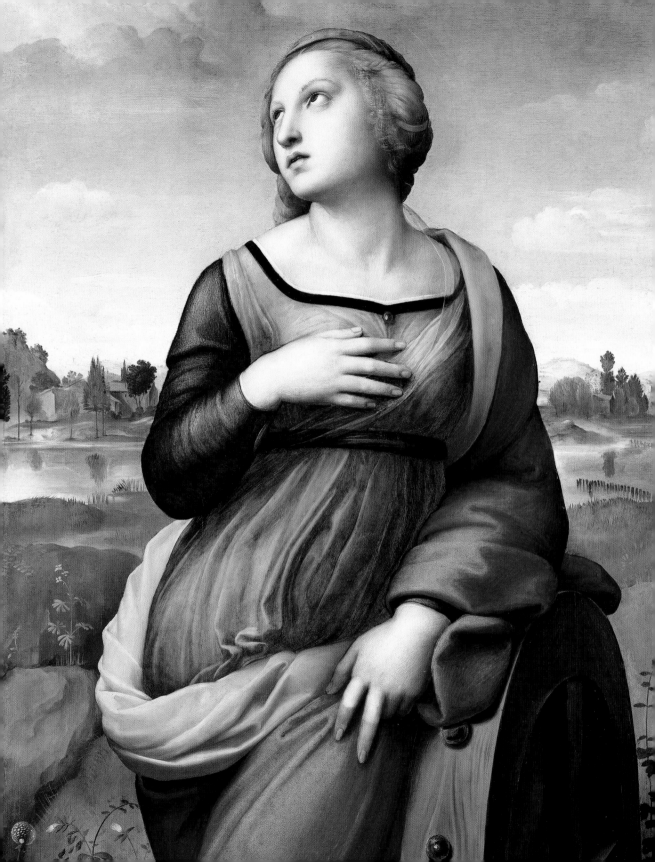

positional sketch for the present painting), and Christ with his arm hanging down perhaps the *Pietà* in St Peter's. The attempt to translate the illustration of grief into facial expressions points to Leonardo. There are no conventional gestures, no pointing or wringing hands or arms raised in lament; what speaks is the action of the bodies, in which pathos and physical effort (carrying and supporting) are meshed. This lends the painting a sense of tension, indeed of exertion, that is perhaps characteristic of this moment in Raphael's career.

The *Madonna del Baldacchino* (p. 20), commissioned in 1506 or 1508 by Bernardo Dei for the family chapel in the Florentine church of Santo Spirito, was probably more or less finished by the time Raphael left for Rome in autumn 1508. It was to be the crowning work of his Florentine years, but the impression it creates is mixed. The figures seek in various ways to communicate with each other and with the viewer, but they seem to lack inner animation; there is no theme to give this *sacra conversazione* its content. Two well-proportioned putti poring over a banderole – the one on the left in the not altogether infantile pose of Polycletus' *Doryphorus* – weaken the distancing motif of the steps leading up to the throne. The background is also classically inspired (perhaps by the architecture of Brunelleschi's Santo Spirito): in place of a view into the landscape, we find Corinthian pillars that correspond to the statuary quality of the figures. A spacious, atmospheric ambiance is created in the niche behind the baldachin; the two angels hover over the heads of the saints with thoroughly earthly realism, their wings beating the air and their draperies fluttering.

At the end of Raphael's Florentine period stands a painting which is singular in several ways: the lone figure of *St Catherine* (p. 26), probably painted for a female customer of the same name. Catherine is leaning against a wheel, the attribute of her martyrdom, but it is through her heavenward gaze, her inner animation, her trust in God and her willingness to suffer that the artist invites us to identify with her. In the complicated torsion of her trunk and limbs we see the lingering influence of Michelangelo's unfinished *St Matthew*, but what in the twisting statue is contrast here resolves itself into a single, harmonious flow of movement. The folds of the draperies follow the body and emphasize its volume; they look forward to the female figures in Raphael's Roman frescos. Of particular interest is the colour scheme of the painting (vigorously cleaned in the 1960s). The simple hues of red, blue, green and yellow that underpin the palette of most of Raphael's early works here appear chromatically broken; the yellow, red and orange of the mantle contrast on the one hand with the luminous ultramarine of the sky and on the other with the cool greyish violet and moss green of the dress and undergarment. The yellow radiates once more, intensified, from the clouds above, as the light of heaven towards which the saint is turning.

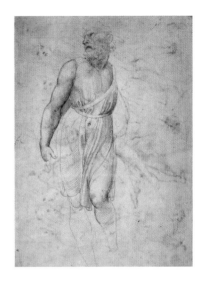

Study after Michelangelo's unfinished statue of **St Matthew**, c. 1505/06
Pen on paper, 23 x 31.9 cm
London, The British Museum, 1855-2-14-1 verso

The contrapposto motif developed by Bertoldo and Michelangelo was one that Raphael first made his own in Florence, and which he retained even into his Roman period; it finds a last echo in *Lo Spasimo di Sicilia* (p. 65).

St Catherine of Alexandria, c. 1507/08
Oil on panel, 71 x 56 cm
London, The National Gallery

With her mouth slightly open, Catherine's expression is a calmer version of the tear-stained face worn by Mary Magdalene in *The Entombment* (p. 25).

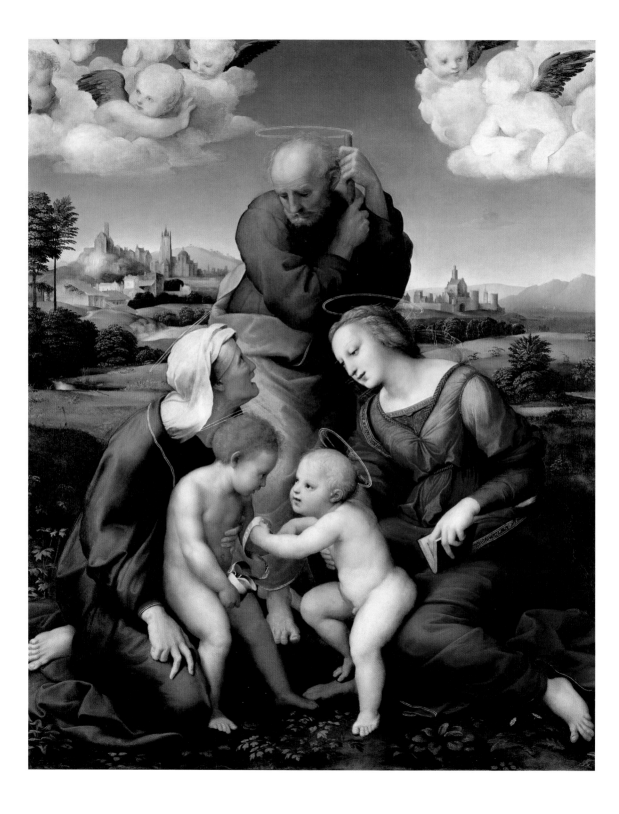

The Madonna

Where the name Raphael is still present in the general awareness, it is connected with the image of the Madonna. More than 20 museums in the Old and New Worlds are able to boast Madonna paintings by Raphael in their collections; their reproductions are – or used to be – a proud part of the furnishings of middle-class homes, where such existed. They were icons of Western civilization.

The Madonna accompanied Raphael through all the phases of his short career. He treated her in every pictorial genre and in every possible combination with other holy personages. The road leading from the first, tentative attempts of his apprentice years to his large Holy Families is a long one, but it runs straight. It thereby remains an astonishing, perhaps unique fact that his Madonna paintings demonstrate no repetitions, no moments of standstill, no complacent satisfaction with existing solutions; no one resembles the other. The demand for pictures of the Virgin suitable for private devotion in the home was undoubtedly enormous, and Raphael was just one of many artists who sought to satisfy it. Yet the Madonna became, for him in particular, something of a lifelong subject. Together with the Venetians, Raphael ranks among the great discoverers of the feminine in painting, and it was the Madonna who first confronted him with this theme. In his later years, too, as the scope of his subject matter broadened and, with the inclusion of pagan mythology, even touched upon the realm of the erotic, the loving relationship between mother and child, and more specifically between mother and son, become a central theme of his œuvre.

The Madonna is not a biblical subject: in the New Testament, the mother of Christ plays a subordinate role. Only later did theologians lend her more substance. The cult of the Virgin was of central importance in shaping the ideas and emotions of Christian Europe. The spectrum of Marian imagery ranges from the feudal Queen of Heaven to the Lives of the Virgin played out in a bourgeois idyll, from the "Beautiful Madonnas" of the late Middle Ages to the idols of a popular faith in which – particularly in Italy – ancient, pre-Christian cults of the Mother live on. But even in these, the Virgin is always more than just a symbol of natural motherly love: the memory of the Passion and the mother's grief at the loss of her son is always present. As well as maternal affection, some of Raphael's Madonnas also demonstrate a sense of awe at the divine nature of their infants – who are usually strikingly big and playing on their own – and a premonition of the suffering to come.

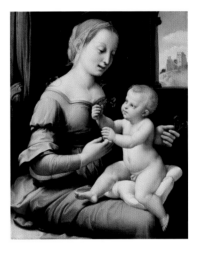

Madonna with the Carnation, c. 1506
Oil on panel, 29 x 23 cm
London, The National Gallery

Until very recently still in a private collection, this small, long disregarded painting was acquired by the National Gallery in London in 2004.

The Virgin, Joseph and Elizabeth with Jesus and John (The Canigiani Holy Family),
c. 1507/08
Oil on panel, 131 x 107 cm
Munich, Alte Pinakothek

Domenico Canigiani, a Florentine cloth merchant, probably commissioned this painting on the occasion of his marriage to Lucrezia di Girolamo Frescobaldi in 1507.

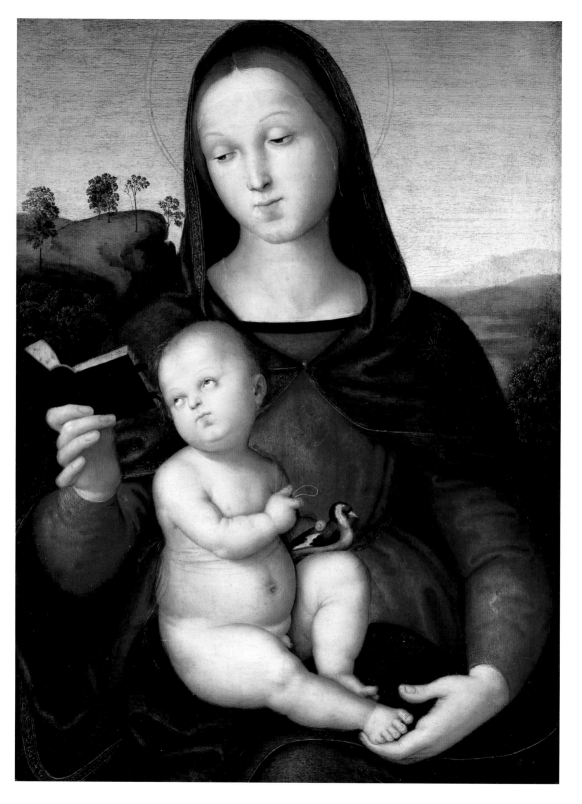

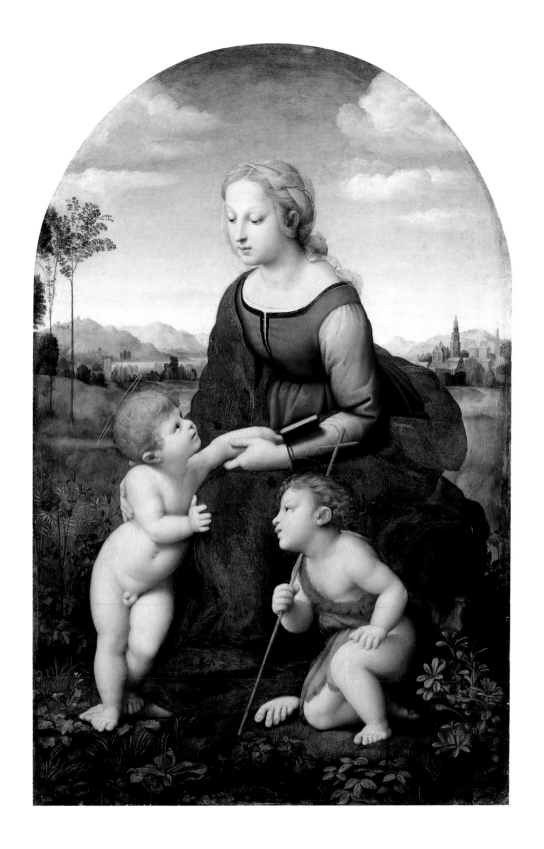

PAGE 30:
Solly Madonna, c. 1502
Oil on panel, 78.9 x 58.2 cm
Berlin, Staatliche Museen zu Berlin – Preussi-
scher Kulturbesitz, Gemäldegalerie

A Florentine cardinal and Dominican theolo-
gian from the start of the 15th century recom-
mended parents to hang in their homes pictures
that "are also pleasing to small children", such as
those of "the Virgin Mary with the Child in her
arms and a little bird or an apple in her hand".

PAGE 31:
*The Madonna and Child with the Infant
St John (La Belle Jardinière)*, 1507/08
Oil on panel, 122 x 80 cm
Paris, Musée du Louvre

Earlier versions of this same subject are found in
the Uffizi (*Madonna with the Goldfinch*, c. 1506)
and the Kunsthistorisches Museum in Vienna
(*Madonna of the Meadow*, 1506).

One of the five or six Madonna paintings from Raphael's Perugian period is the *Solly Madonna* (p. 30) in Berlin. Like countless Virgins before and after her, she is studying her prayer book with quiet devotion, and the Child looks at the pages with her – a motif that Raphael would restate with very much greater life in compositions to come. The goldfinch with which the Infant is playing can be interpreted as a symbol of the soul and also as a reference to the Passion, although details of this kind were also often understood by contemporary viewers as pure-ly genre motifs. More important for Raphael was an empathy with the scene portrayed ("He is always as little symbolic as possible," believes Burckhardt).

In Florence Raphael's Madonnas quickly became very popular; they gained him access to the city's wealthy and influential families, with whom he also mixed socially. Not all these paintings are masterpieces, but each offers a new in-sight or processes a new source of inspiration. The example of Leonardo, and perhaps also the atmosphere of the city as a whole, newly relieved of the op-pressive Savonarola, bring about a cosmetic revolution: Raphael's Madonnas go blonde. The *Madonna with the Carnation* (p. 29), a sort of paraphrase of Leo-nardo's *Benois Madonna,* is a young mother in an elegant housedress who is playing with her child, a smile on her face. As with Leonardo, we find ourselves in a semi-dark interior, with the landscape outside glimpsed through a window.

Raphael also explored the theme of a seated mother with two standing or kneeling children, a combination that Leonardo had earlier addressed in the *Vir-gin of the Rocks* and which offered new formal and intellectual possibilities. With the introduction of the second child, the composition accordingly becomes more complex. Leonardo's cartoon for the *Virgin and Child with St Anne* had meanwhile gone on display, and Michelangelo was working on his *Bruges Madonna.* Impulses from both works are found in three Raphael paintings in which the Virgin is placed within (and no longer in front of) an idyllic land-scape, looking down at the two children playing at her feet. The three-way con-versation is most intense, the synthesis most sublime in *La Belle Jardinière* (p. 31) in the Louvre: the infant John with his staff kneels before Jesus, who leans close against the knee of his mother, who in turn looks down at him. The looks ex-changed pass from John to Jesus and from Jesus to Mary, accompanied by a ges-ture, as if the Infant wishes to explain the situation to his mother.

Offering opportunity for exploration, too, was the subject of the Holy Fam-ily, to which Raphael turned towards the end of his Florentine period. He had already attempted to combine Joseph, the Virgin and Child with a lamb in a composition of 1504, employing the falling diagonal of Leonardo's *Virgin and Child with St Anne* but failing to achieve the same melodious cascade. *The Cani-giani Holy Family* (p. 28) which followed three or four years later can be seen as an antithesis to this earlier attempt: five figures form an artfully balanced pyr-amid, at the centre of which hands and feet overlap in complex profusion. The cherubs in the clouds, only recently uncovered, align the painting in terms of content with Raphael's large altarpieces.

With his move to Rome, Raphael's period of formal experimentation is for the time being over – but not his development and deepening of his subject matter. Raphael's Madonnas grow more maternal, their children more childlike, playing unselfconsciously with a flower (*Aldobrandini Madonna*) or with their mother's veil (*Madonna di Loreto*). The *Madonna della Sedia* (p. 33) dates from the same period as the Stanza d'Eliodoro frescos. It stands apart from Raphael's other Madonnas on three counts: the concentration of all three figures into the rondo in extreme close-up; the fact that mother and child are both looking at

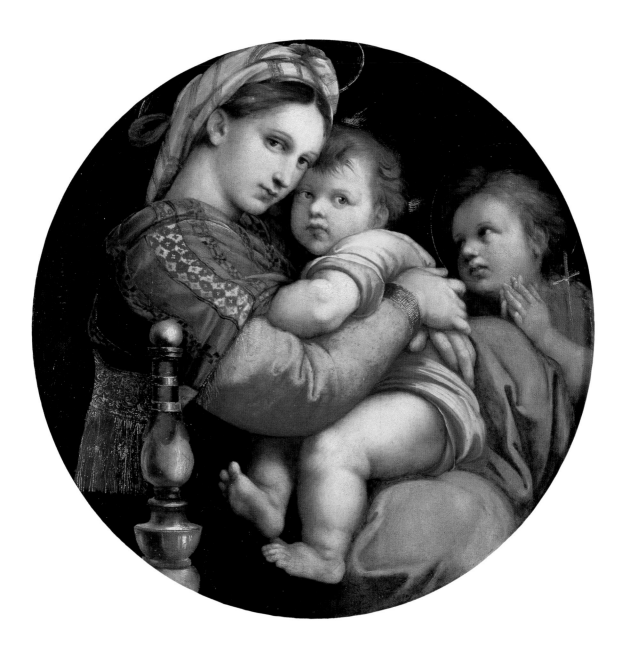

the viewer; and the painterly brilliance with which the artist depicts even subsidiary details such as the turned upright of the chair and the fabrics shot with gold. All these evoke an atmosphere of almost portrait-like intimacy found in no other Raphael Madonna. The palette, too, is singular. The Virgin clasps her young son, long past babyhood, tightly to her with both arms, as if unwilling to part with him. His little arm disappears under her shawl. The infant John has no share in the communion of mother and son.

Raphael subsequently produced no more Madonna paintings of comparable intensity. Instead, he went on to design a series of multi-figure compositions in which the religious subject of the Holy Family crosses over, as it were, into the

Madonna della Sedia, c. 1513/14
Oil on panel, diameter 71 cm
Florence, Galleria Palatina

In Florence, circular representations of the Virgin (a format called the tondo) enjoyed a tradition dating back to the Middle Ages. Raphael would have encountered them in the sculpture of Luca della Robbia and Michelangelo and in the painting of Sandro Botticelli, Lorenzo di Credi and Filippino Lippi.

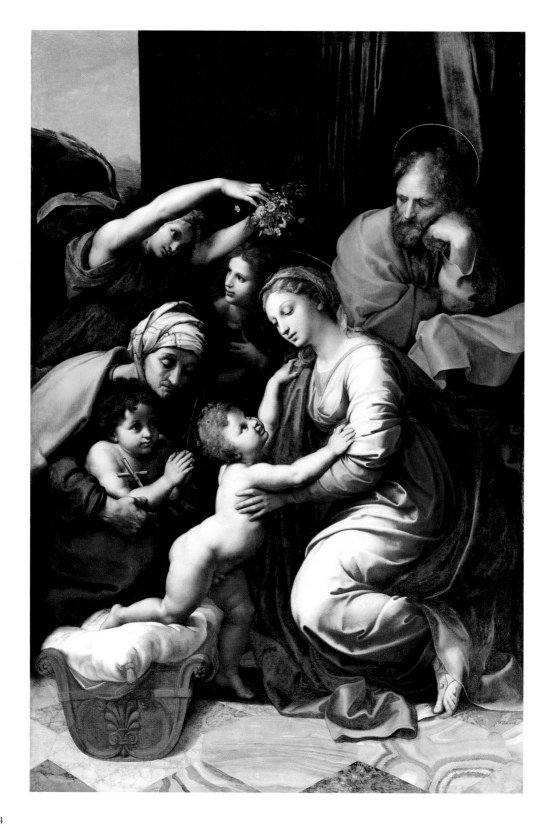

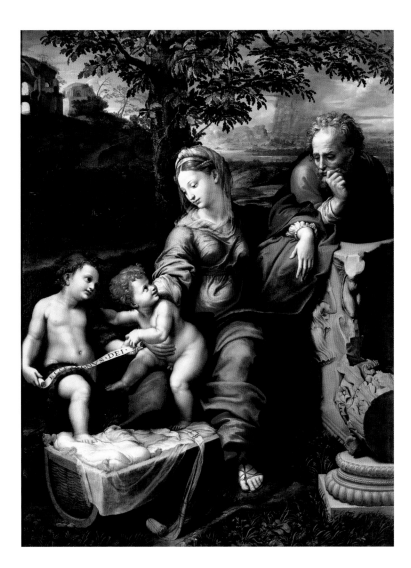

**The Holy Family beneath the Oak Tree
(Madonna della Quercia)**, c. 1519
Oil on panel, 144 x 110 cm
Madrid, Museo del Prado

While Raphael's hand can be identified in the
underdrawing (revealed by X-ray), he left the
actual painting to Penni and Giulio Romano.
The background landscape is nevertheless one
of the most beautiful of Raphael's late works.

The Holy Family of François I, 1518
Oil on canvas, transferred from panel,
207 x 140 cm
Paris, Musée du Louvre

The Infant Jesus steps out of his cradle like
Christ rising from the tomb. The Virgin is
crowned Queen of Heaven with a wreath of
flowers.

sphere of the official public statement. His clients included Pope Leo X, who
commissioned *The Holy Family of François I* (p. 34) as a gift for Queen Claudia of
France and had the painting delivered personally by his nephew Leonardo. The
clearly visible text RAPHAEL URBINAS PINGEBAT MDXVIII emphasizes the
value of the gift but should be taken with a pinch of salt: none of these paintings
is today thought to have been painted entirely by the master himself. Their pal-
ettes are sombre and rich in contrast, and antique ruins appear in their back-
grounds. Raphael's interest in classical archaeology in his latter years culminates
in the *Madonna della Quercia* (p. 35): the Madonna is based on an antique cameo
and leans against the base of a candelabra. The base of a broken column from the
Temple of Mars Ultor lies in the right-hand foreground, while the so-called
Temple of Minerva Medica and another circular building known from contem-
porary drawings can be made out in the background. All of this of course serves
to symbolize the triumph of Christ over the world of pagan belief.

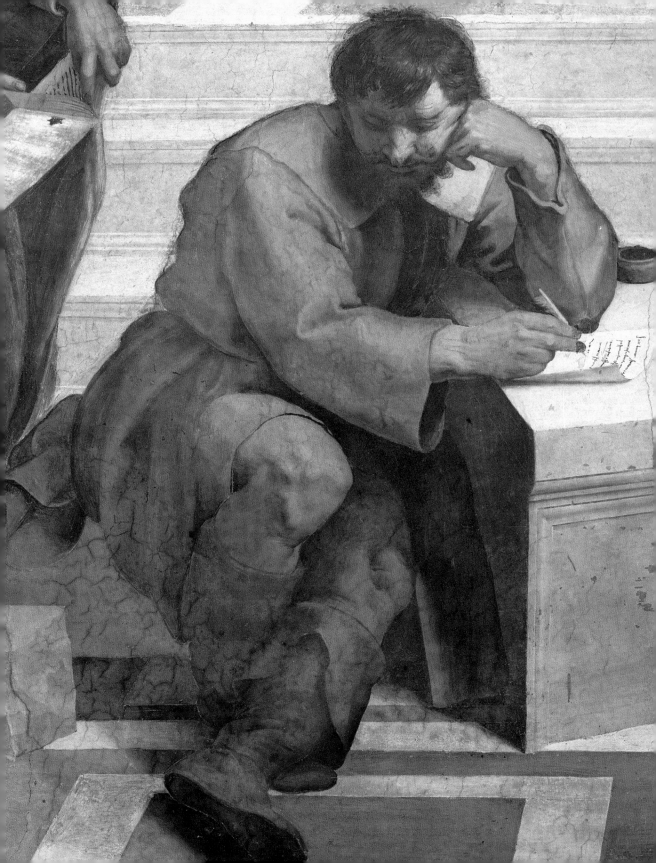

Painter in the Vatican

The modern-day tourist in Rome experiences the Vatican as a state within a state, cut off from the life of the metropolis outside. In Raphael's day, however, despite its peripheral location, the Vatican was the hub of the city: it housed the court. As painter to the papal court (on a fixed salary as a *scriptor brevium,* a drafter of papal breves), in autumn 1508 Raphael entered the social sphere in which he would remain until his death. The 25-year-old had, quite literally, arrived. It was here that he would achieve celebrity status and his greatest successes. But if his life took on a firm framework, the restlessness which drove him to set new goals for his art year after year showed no signs of letting up. Some scholars have attributed the increasing grandiosity and monumentality of the artist's style to the impression made upon him by the Eternal City. In truth it was he himself – as a consequence of his assimilation of Michelangelo first in Florence and subsequently in Rome – who created the *maniera grande* of the Roman High Renaissance. Raphael now found himself confronted with three entirely new things: the commission to execute the fresco decoration of large secular interiors; the intellectual climate within the Curia, where Italy's leading theologians rubbed shoulders with its finest humanists and most learned scholars of the arts and classical antiquity; and a patron in the shape of della Rovere pope Julius II. Raphael responded positively to all three challenges. Over the following few years he developed a new style of wall-painting and created a cosmos of allegorical and historical figures and scenes whose interpretation continues to occupy the academic world right up to the present. Furthermore, in conjunction with Bramante and Michelangelo, he created Julius II's image as the "Renaissance Pope" – an image that continues to outshine all the hostile criticism levelled at him by his own contemporaries.

Raphael's *Stanze* (rooms) make up the papal apartments that Julius II furnished for himself on the upper floor of the Vatican palace. They already contained frescos by Piero della Francesca, Perugino and Signorelli, but Julius decided to have the suite entirely redecorated. He proceeded to engage a team of younger painters, including Sodoma, Peruzzi, Bramantino, Ripanda and Lotto, but then Raphael arrived from Florence on Bramante's recommendation and ousted all the rest. He embarked first upon the middle chamber, containing the pope's probably fairly modest library ("io non so lettere" – "I am not educated" – Julius is supposed to have said of himself). The modern-day designation of the

The Stanza della Segnatura

Left: *Parnassus*; right: *The School of Athens*. Allegorical figures corresponding to each mural appear in the tondos in the vault overhead: Theology above the *Disputa*; Poetry above *Parnassus*; Philosophy above *The School of Athens*; and Justice above *Justice*. They are accompanied in the rectangular fields between them by explanatory scenes: The Fall, Apollo and Marsyas, Urania with the celestial globe, and the Judgement of Solomon.

Heraclitus, 1510/11
Detail from ***The School of Athens*** (pp. 40–41)

This figure is absent from Raphael's cartoon, today on display in the Ambrosiana in Milan. Raphael had the corresponding area of the fresco, which was already finished, chipped out and re-executed.

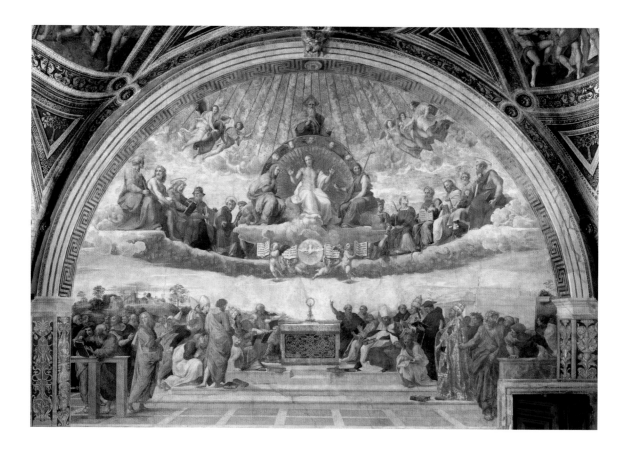

Disputa, 1508/09
Fresco, c. 10.75 m wide
Rome, Palazzo Vaticano, Stanza della Segnatura

In the lower, terrestrial zone of the painting, the
vanishing lines of the perspective construction
converge in the host on the altar towards the
rear. In the celestial sphere above, the Trinity
floats closer to the front, in the centre of the
upper zone.

chamber as the Stanza della Segnatura derives from its subsequent use as a papal
courtroom. Its decoration (p. 37) reflects the syncretist thinking of Roman hu-
manism: the walls are peopled by figures from the Bible and mythology and by
the writers and thinkers of antiquity and the Middle Ages, with Christ, Apollo,
Plato and Aristotle as protagonists. On the ceiling, four seated female figures
symbolize different paths to spiritual enlightenment – Theology, Poetry, Philo-
sophy and, as the fourth, Justice as the principle guiding human behaviour on
earth. To these personifications correspond, respectively, the four wall-paintings
of the *Disputa* (p. 38), *Parnassus* (p. 39), *School of Athens* (pp. 40–41) and *Justice*
(p. 42). The scheme may go back to Tommaso Inghirami, the pope's close con-
fidante and probably his private librarian. Raphael painted his portrait two years
later (p. 85), and in the *School of Athens* he appears as Cicero (on the left-hand
edge, wearing a wreath). No mention is made anywhere, however, of a written
programme that might have set out more than simple instructions, such as a list
of individuals to be portrayed. Whatever the case, it was Raphael's job to trans-
late the suggestions passed on to him into a picture – a task which placed the
highest demands on his intelligence, imagination and powers of invention.

The *Disputa* was the first Roman test of Raphael's talent; one might also call
it a test of his courage. The composition is based upon a lost fresco of the Last
Judgement by Fra Bartolomeo, which Raphael had already drawn upon in 1505
for the decoration of the apse of San Severo in Perugia. Here he develops it into
a celestial vision of grandiose spaciousness. There is no absence of gold, no

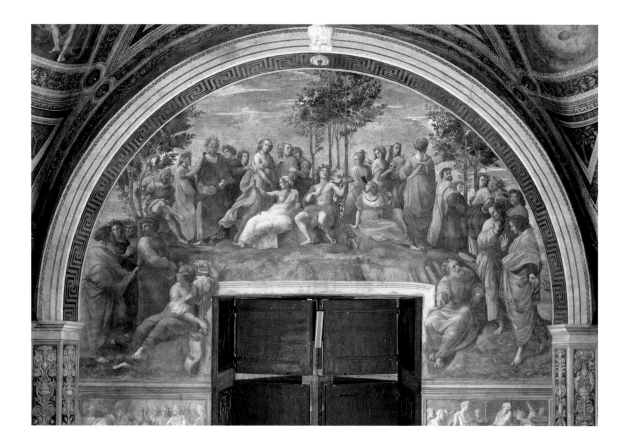

doubt much to the pleasure of the pope (who would miss it in Michelangelo's Sistine ceiling). Only over the course of the design process, which is documented by more than 40 drawings, did the theological message slowly evolve its final formulation. In the centre of the composition, on the altar, stands the monstrance containing the consecrated host, the embodiment of the mystery of the Eucharist. In the heavens above it appears the Trinity, flanked by the Virgin and St John, with the four Gospels beneath them. Prophets, apostles and saints have arranged themselves along a semi-circular bank of cloud extending in two arms along either side. On the ground beneath, Raphael mixes individuals from church history with invented, anonymous figures. His chief concern was to infuse the assembled throng with movement and life, and for this Leonardo's *Adoration of the Magi* in Florence provided decisive stimuli. The resulting impression is of a Disputation of the Holy Sacrament (or *disputa,* as Vasari terms it). Perhaps this was also intended as a reminder of a Vatican disputation of 1452, in which Francesco della Rovere, Julius' uncle and future pope Sixtus IV, defended the Corpus Christi as singularly holy. He appears here in the standing figure of the pope in the golden cope in the right-hand foreground. Julius himself, still without a beard, is seated to the left of the altar.

The window in the north wall of the Stanza offers a view of the top of Vatican Hill; to the Roman humanists, this was held to be *Parnassus,* seat of Apollo and the Muses. Raphael visualizes it as a rocky plateau where the Castalian spring has its source. Apollo appears surrounded by the nine Muses, with 18 Greek,

Parnassus, 1509/10
Fresco, c. 8.70 m wide
Rome, Palazzo Vaticano, Stanza della Segnatura

Apollo is making music upon a modern stringed instrument (a lira da braccio). The instruments held by the Muses are copied from a Roman sarcophagus in the Vatican.

PAGES 40–41:
The School of Athens, 1510/11
Fresco, c. 10.55 m wide
Rome, Palazzo Vaticano, Stanza della Segnatura

Just a few decades after Raphael, it seemed unthinkable that a pope should have his apartments decorated with pagan philosophers. Plato and Aristotle were therefore interpreted as St Peter and St Paul, the scribes as the Evangelists, and so on.

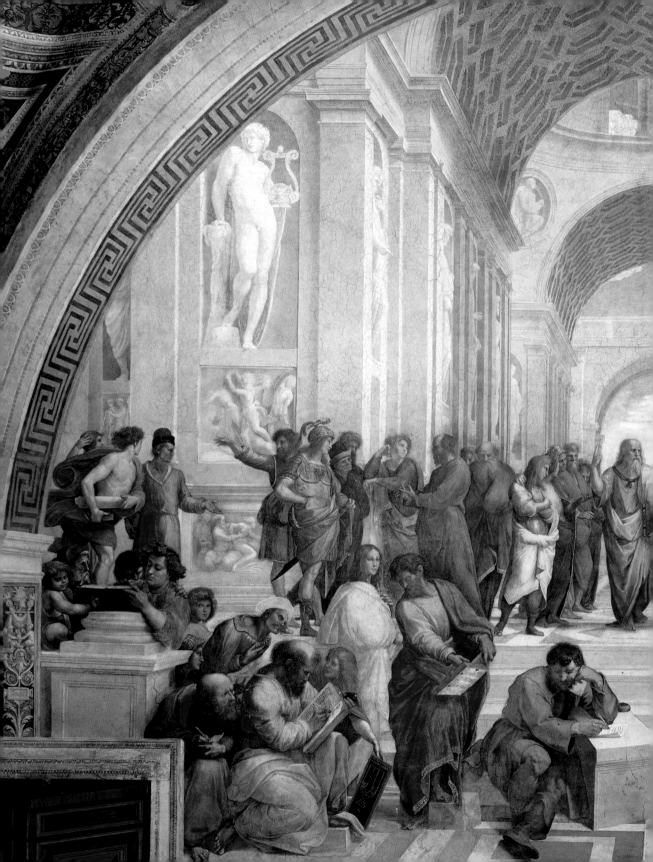

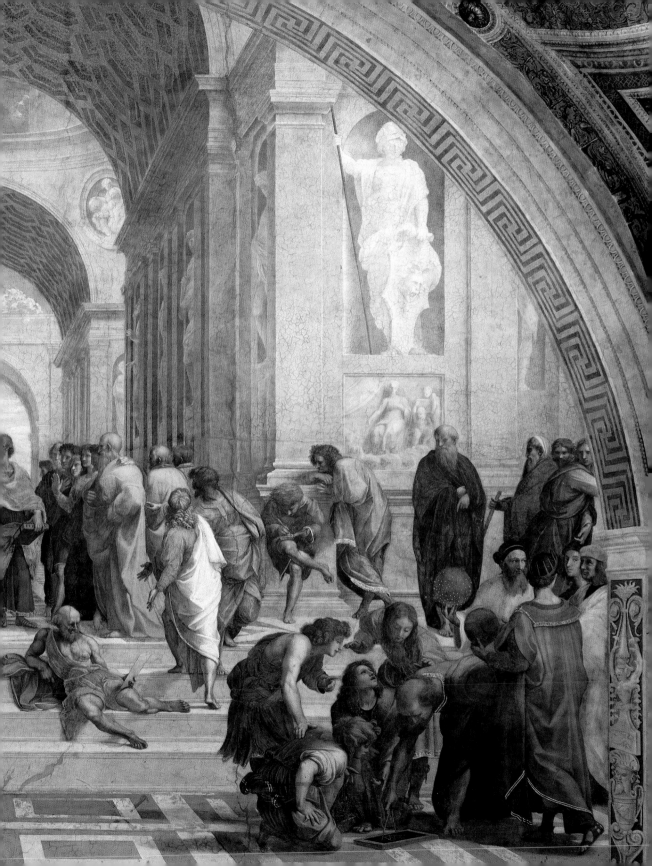

Justice, 1511
Fresco, c. 8.60 m wide
Rome, Palazzo Vaticano, Stanza della Segnatura

Civil and ecclesiastical jurisprudence, represented by the scenes on either side of the window, combine to illustrate *Justice*, one of the four Cardinal Virtues. The remaining three appear in the lunette.

Latin and Italian writers grouped on the slopes of the mountain around him. While classics such as Dante, Homer and Virgil are easy to recognize, others can only be guessed at, and many a pleasurable hour must have been spent arguing over the correct identification of the Muses even in Raphael's own day. A key factor here is the feminine element introduced by these same Muses and the poetess Sappho (bottom left). Delicate and bright colours in subtle nuances evoke the lyrical mood of the whole. The arrangement of the figures is unforced, harmonious, their faces measured, not caught up in heated argument as in the *Disputa*. Certain drastic illusionisms in the figures of Sappho and Pindar (?) beside the window are the last of their kind; in the frescos of the following Stanze, Raphael turns his back on such effects.

With *The School of Athens* we return to a world solely of men. The School (the name is derived from Bellori, who in 1695 described it as "the Gymnasium of Athens") or rather the Temple of Philosophy (according to Marsilio Ficino) is an open, spacious building decorated with reliefs and statues of the gods. Philosophy is by definition the wisdom of the ancients: modern (i.e. Christian) thinkers do not appear. In the centre stand the two heads of the School: Plato, his *Timaeus* tucked under his arm, points upwards at the realm of ideas, while Aristotle, holding his *Ethics,* gestures towards the earthly domain. On the left, on the

same level as Plato, we can recognize a bulbous-nosed Socrates conversing with a cluster of Athenian citizens (including an elegantly dressed Alcibiades), and in the foreground, writing, Pythagoras surrounded by a group of students. Diogenes is sprawled on the steps with his drinking cup, all cares forgotten. In the right-hand foreground, a balding Bramante as Euclid is explaining the laws of geometry to his youthful pupils. Raphael – who himself appears further right, at the very edge of the painting – was indebted to Bramante not just for architectural inspiration, but perhaps also for pointing him towards classical writings on the lives and appearances of the philosophers (Lasse Hodne). Raphael's problem was once again to translate an abstract subject into action. What do philosophers do? They converse, argue, read and write, teach or spend time meditating alone. Infusing all of this is the power of the intellect, bringing life and animation. *The School of Athens* thereby becomes the clear antithesis to the *Disputa* (understanding being attained there through revelation, here through reason), but the comparison also illustrates Raphael's artistic development: the brushstroke has become more confident, broader, more painterly, the figures weightier, more solid, the composition richer and freer, the palette more harmonious. Raphael has found his fresco style (and will carry it tempestuously further in the Stanza d'Eliodoro).

While Raphael was painting on the scaffolding in the Vatican Stanze, Michelangelo was working behind closed doors on the ceiling of the Sistine Chapel. On 14 August 1511 the first half of the ceiling was unveiled; the impression was enormous. Raphael reacted, typically enough, with a call for a dialogue: into the already finished *School of Athens* he inserted – in an imitation (or parody) of Michelangelo's style – a portrait of his rival as a sombre (weeping) Heraclitus, leaning against a block of marble and staring broodingly before him (p. 36). Shortly afterwards Raphael painted *The Prophet Isaiah* (p. 57) in S. Agostino, a powerfully animated seated figure in the manner of the Sistine prophets (and of the *Moses* statue on Julius' tomb), but open, affable and not absorbed within himself like the figures of Michelangelo.

The *Justice* wall (p. 42) does not mesh entirely smoothly with the themes of the three others in the Stanza della Segnatura; it may go back to a decorative programme illustrating the Four Faculties, as traditional for libraries and perhaps originally planned for this room, too. Raphael underlines the difference between it and the others by dividing the wall into individual fields, rather than incorporating the entire wall into a scenic composition around the window, as in the *Parnassus*. The painted architecture framing the fields is based much more directly upon Bramante than it was in *The School of Athens*. The lunette contains the seated figures of Fortitude, Prudence and Temperance; together with Justice in the tondo of the vault, they make up the quartet of Cardinal Virtues, upon which the human system of jurisdiction is or ought to be based. Although their kinship with the sibyls of Michelangelo is undeniable, the three female figures establish mutual connections through their gestures and poses and form themselves into a social ensemble.

The scenes on either side of the central window represent civil and ecclesiastical law and together illustrate Jurisprudence. Only the right-hand scene is by Raphael; an assistant, probably Lorenzo Lotto, executed the one on the left. It shows Emperor Justinian accepting the *Digest*, the first part of the body of Roman civil law (*corpus juris civilis*), from its author, Byzantine jurist Tribonianus. On the right, Raymund of Penafort is presenting pope Gregory IX with the *Liber Extra* of the *Decretals*, a collection of papal decrees forming the basis of canon

The Mass at Bolsena, 1512
Fresco, c. 8.40 m wide
Rome, Palazzo Vaticano, Stanza d'Eliodoro

The main figure is the Pope in prayer; the mystery of transubstantiation, as such impossible to depict, is illustrated by the story of a German priest, whose scepticism is allayed when the host miraculously begins to bleed as he conducts Mass at Bolsena in 1263.

law (*corpus juris canonici*). Raphael has given the pope the features of Julius II; standing behind him are cardinals de' Medici and Farnese, the future popes Leo X and Paul III – a constellation that incorporates half a century of Vatican history. With his passage from allegory to historical realism and a portrait *dal naturale* within one wall, Raphael distances himself from dangerous proximity to Michelangelo and becomes the "pittore universale" (Vasari) to whom we owe the miracle of the Eliodoro frescos.

The decoration of the Stanza della Segnatura was still incomplete when Julius II returned, ill and defeated, from a campaign against French and imperial troops in northern Italy. At home, he was threatened by a hostile faction of cardinals demanding the convocation of a Council. But his courage was unbroken. Hence he commissioned Raphael to depict, in the following Stanza, God coming to the aid of His people even in seemingly hopeless situations. Four episodes were selected from the Bible and the history of the Church: *The Expulsion of Heliodorus* (pp. 46–47), a Syrian officer who, on the orders of King Seleucus, attempted to plunder the treasure of the Temple of Jerusalem; *The Release of St Peter* (p. 45) from Herod's dungeons; *The Repulse of Attila* (p. 49) by pope Leo I at the Italian frontier; and *The Mass at Bolsena* (p. 44), during which the host begins to bleed and thereby convinces the priest celebrating the mass of the real presence of Christ in the eucharist. They stand for the successful overturning of attacks on the Church's worldly possessions, on the person of the pope, on the Papal States and on the doctrine of transubstantiation as the central dogma of the Christian religion. It is the programme with which Julius, according to Jakob

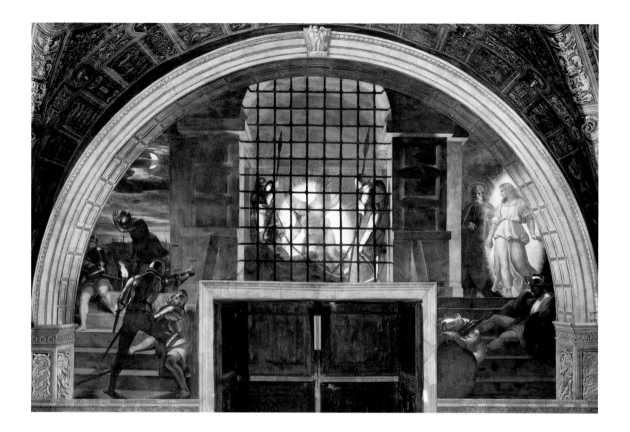

Burckhardt, aimed to make himself the "saviour of the papacy" (in its outer form of a territorial princedom both ecclesiastical and secular). The subject matter was novel, and for Raphael it evidently went hand in hand with a new degree of creative freedom. For Julius could surely hardly have imagined what Raphael would make of his instructions: a succession of human dramas, reflected for example in the face of St Peter as he is led out of prison by the angel, a moment described in the Acts of the Apostles thus: "And he went out, and followed him, and wist not that it was true which was done by the angel; but thought he saw a vision." (Acts 12, 9) And again in the figure of the young priest in *The Mass at Bolsena,* who registers the blood on the host with a burning face and downcast eyes, ashamed at his previous scepticism.

The ecclesiastical programme as a whole may be conservative, but Raphael was nevertheless a man of the Renaissance, and if the pope believed in the unchanging face of history – as was always the case and will continue to be so – the painter considered it his task to bring the past into the present, to embed it firmly within the 16th-century world of experience. Rarely has this task been achieved with such sophistication. God plays his part through envoys, either angels or apostles, while in *The Mass at Bolsena* He is invisibly present in the consecrated host. The miraculous nature of the events portrayed is conveyed solely through the reactions with which they are met in the real world. Serving as figures of identification are three of Julius's predecessors: the high priest Onias, praying in the background in *The Expulsion of Heliodorus,* St Peter in *The Release of St Peter* and Leo I in *The Repulse of Attila.* In *The Mass at Bolsena* Julius appears as his

The Release of St Peter, 1513/14
Fresco, c. 8.10 m wide
Rome, Palazzo Vaticano, Stanza d'Eliodoro

The fresco follows Acts of the Apostles 12,6ff. Vasari considered that "as a work reproducing the effect of night this picture is truer than any other". The three natural sources of light – torch, moon and dawn sky – are deliberately subdued, allowing the angel to assume a truly supernatural brilliance.

PAGES 46–47:
The Expulsion of Heliodorus, 1511/12
Fresco, c. 10.80 m wide
Rome, Palazzo Vaticano, Stanza d'Eliodoro

According to the Second Book of the Maccabees, there appeared in the Temple "a horse that was finely adorned, on which sat a terrible rider" and "two young men, who were beautiful and strong, who stood on either side of Heliodorus and rained blows upon him, so that he fell unconscious to the ground".

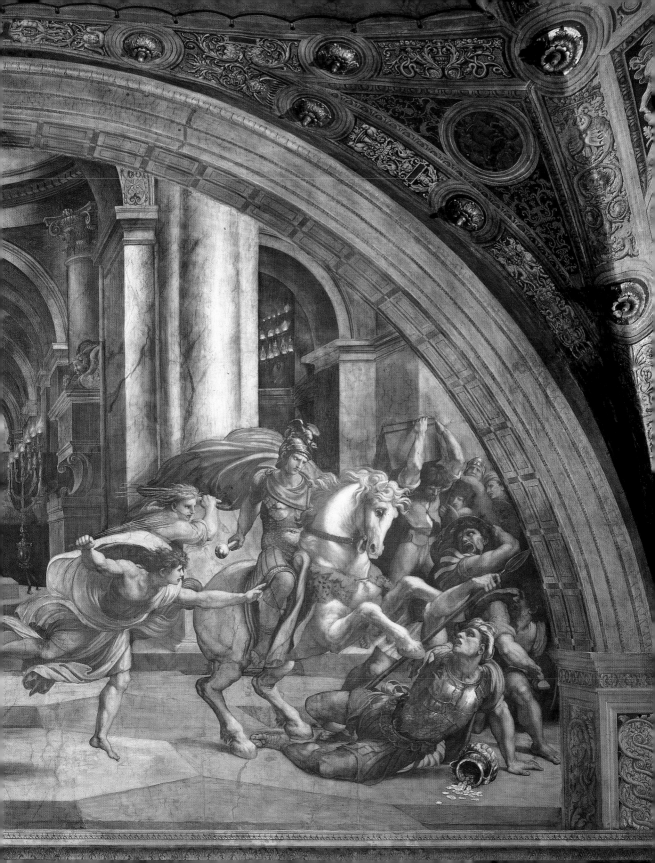

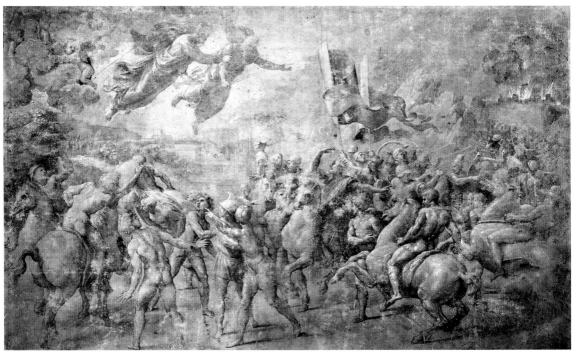

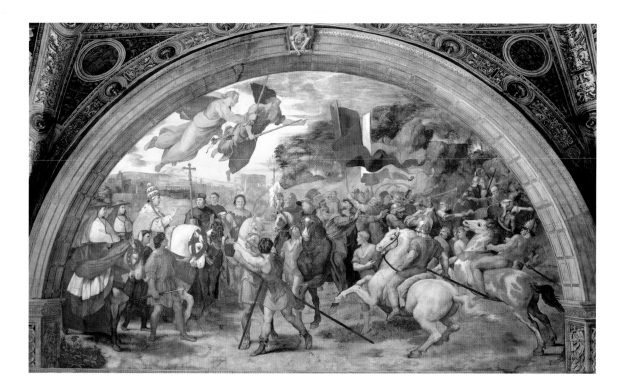

own self, not playing a historical role. The paintings also contain their own spectators, be it in the shape of a crowd of onlookers emotionally caught up in events or, as in the right-hand half of the *Mass*, in the form of an observer maintaining his distance. They help us to experience the story for ourselves, to see it with our own eyes. In *The Expulsion of Heliodorus* it is the pope himself, being borne into the scene from the left, who enables us to savour for ourselves his grim satisfaction at such divine retribution.

The papal group does not appear in the preliminary drawing for the *Expulsion*; it was one of those last-minute additions that Raphael frequently made to his compositions in order to enrich them, lend them additional depth and place them in a new light. Unfortunately for us, the design process behind the Stanza d'Eliodoro frescos is difficult to reconstruct as so few preliminary drawings have survived. Of these, the most interesting relate to *The Repulse of Attila*. We know the first version of the composition from a copy: the papal train and barbarian army enter from opposite sides and come face to face in the centre (p. 48 above). In a second drawing by Raphael's own hand (but in poor condition and so reproduced here in a copy), the entire foreground is now occupied by Attila's hordes (p. 48 below). Two soldiers have spotted the papal train approaching from the depths of the composition and are informing their general, but the latter – to whom the miracle is addressed – can already see the two sword-bearing angels descending towards him. The pope would in this case only have been visible in the background; the messengers of God are the real actors. The idea is magnificent, but in the final fresco only fragments of it are to be seen. Attila (on the black horse with the white blaze on its forehead) almost disappears into the mass of cavalry, which has been thrown into confusion because the pope is now

The Repulse of Attila, 1513/14
Fresco, c. 10.70 m wide
Rome, Palazzo Vaticano, Stanza d'Eliodoro

Raphael's source for this event was the *Lives of the Popes* published in 1474 by Platina (Bartolomeo Sacchi), whom Sixtus IV had appointed praefect of the Vatican library.

PAGE 48 ABOVE:
Copy after Raphael's first design for
The Repulse of Attila
Brush, brown ink on paper, 38.8 x 58 cm
Oxford, Ashmolean Museum

PAGE 48 BELOW:
Copy after Raphael's second design for
The Repulse of Attila
Pen and wash on paper, 35.2 x 59.8 cm
Paris, Musée du Louvre, Inv. 4145

Raphael's original drawing, also in the Louvre, is in very poor condition and difficult to reproduce.

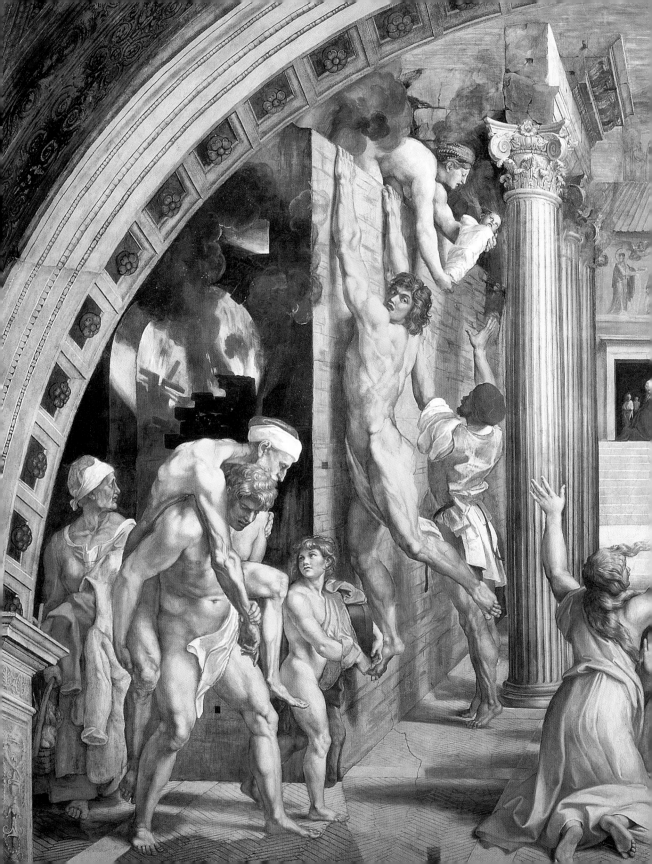

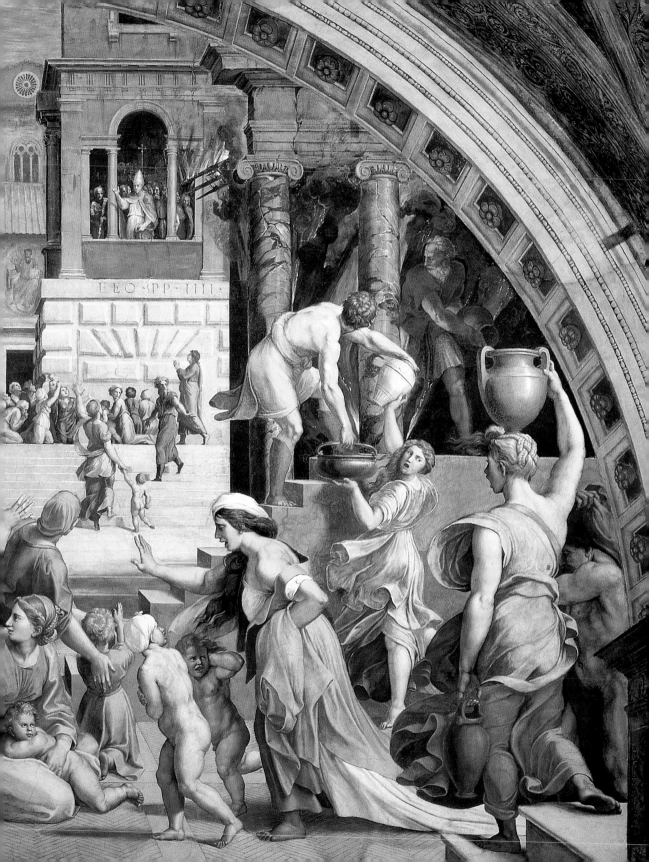

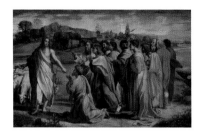

The Donation of the Keys ("Feed my sheep"),
1515/16
Tempera on heavy paper, 345 x 535 cm
London, Victoria and Albert Museum

PAGES 50–51:
The Fire in the Borgo, 1514
Fresco, c. 10.60 m wide
Rome, Palazzo Vaticano, Stanza dell'Incendio

The Borgo and the Vatican Palace with its bene-diction loggia are imagined as buildings of An-cient Rome; in the background, St Peter's pre-sents its old façade, as it still stood in Raphael's day. In his *Mnemosyne* atlas of pictures, Aby Warburg brings together all the forerunners of Raphael's figure. They extend right back to a Byzantine ivory of the 7th century.

The Miraculous Draught of Fishes, 1515/16
Tempera on heavy paper, 360 x 400 cm
London, Victoria and Albert Museum

The two tapestries hung next to each other and their sceneries were linked: on the right-hand edge of *The Donation of the Keys* can be seen the prow of the canoe in which Jesus is sitting in *The Miraculous Draught of Fishes*. The car-toons were reversed on the loom, and hence in the finished tapestry series the *Miraculous Draught* precedes the *Donation*. Christ appears on the right-hand edge, lending his figure greater weight.

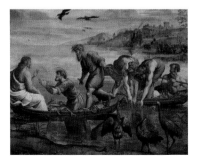

approaching from the left again. He is not being borne in on a throne, however, but – as in the Louvre drawing – is mounted on horseback. He is Leo X, the Medici pope who has succeeded Julius II following the latter's death and who wishes to make his entry into the Stanze as grandly and impressively as his pre-decessor on the opposite wall.

The frescos in the Stanza d'Eliodoro revolutionized the genre of history painting, even if no one realised it at the time: it is all too easy for us, with our knowledge of later painting, to take for granted what in those days must have seemed like a revelation. As a snapshot of an unfolding event, the composition of *The Expulsion of Heliodorus* is without compare; even Leonardo had set no precedent, any more than for the three avenging angels ("Christian Furies", An-tonietta Zancan) who burst in like a hurricane and charge down the intruder. At the opposite end of the spectrum is the unruffled serenity of the pope kneeling in the background: his presence is sufficient, no gesture is needed. No less aston-ishing is the papal retinue in *The Mass at Bolsena*: cardinals, bishops and pre-lates, *palafrenieri* (throne bearers) and members of the Swiss Guard reproduce the papal court hierarchy to perfection, but in a fashion whereby that same hier-archy is bypassed. The artist offers us instead a group of men who have come to-gether for this one moment and whom he observes as separate individuals. The eyes of one Swiss Guard graze the viewer as if by chance. The loose, spontaneous brushstroke shows Raphael at the height of his ability as a fresco painter. This is true, too, of his new approach to colour: it no longer serves the distinction of figures each outlined for itself, but creates moods and unites groups of people (most grippingly in the right half of *The Repulse of Attila*). In *The Release of St Peter* Raphael renounces any kind of delicate drawing, trusting the entire story to the effect of the light. Not until the painting of the 17th century was anything similar attempted (and rarely achieved).

Julius's successor Leo X allowed Raphael no pause for breath; on the con-trary, the demands placed on the Vatican court painter only grew. Raphael had to set priorities, and he started leaving the execution of his designs increasingly to his pupils and workshop assistants. His studio grew into a large-scale enter-prise, in which artists of all different kinds and origins worked alongside each other, inspired by the genius of the master and held together by his powerful personal charisma. In the third Stanza, the only fresco to be executed by Raphael himself was *The Fire in the Borgo* (pp. 50–51), which gave the room its name (Stanza dell'Incendio). It testifies to a profound shift in his interest. It depicts the fire that broke out in 847 in the Borgo quarter just outside the Vatican walls and its miraculous quenching by pope Leo IV, who appears in the Loggia della Benedizione on the front of the Vatican Palace. Raphael has on this occasion checked his painterly imagination: the fire is raging only at the edge of the com-position, while the foreground is given over – as in *The Repulse of Attila* – to the reaction of the onlookers. But if the miracle itself is here rather less dramatic, Raphael's narrative style shifts into the theatrical, perhaps under the influence of Aristotle's theories on drama, at that time the subject of discussion in literary court circles. Thus the scene is peopled with individual figures striking theatrical poses, where possible naked as in classical antiquity; in the left-hand fore-ground, for example, Virgil's Aeneas is rescuing his father Anchises from the burning Troy. Associations with antiquity are also evoked by the – deliberately stage-like – architecture. The palette is subdued, but with a mellowness and wealth of nuance to which none of the other paintings in the Stanza come even remotely close. The fresco owes its greatest fame to a subsidiary figure on the

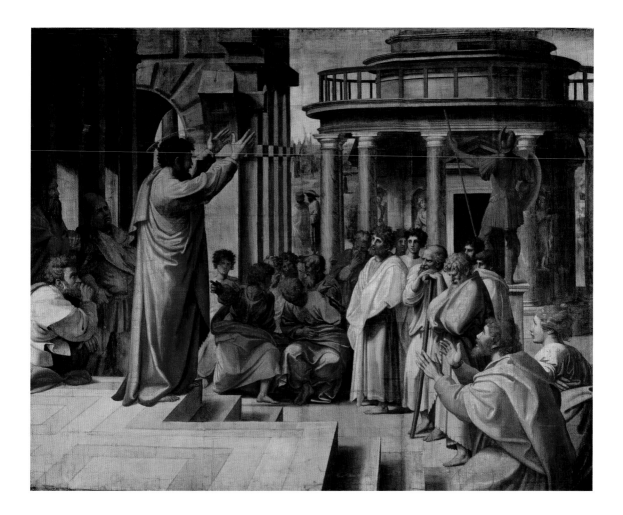

right-hand edge of the composition, the woman carrying water, her draperies billowing in the wind from the inferno.

 In the years that followed Raphael was chiefly occupied on the production of the cartoons for a series of ten tapestries illustrating the Acts of St Peter and St Paul. They were destined for the Sistine Chapel, where they were to hang beneath the frescos commissioned by Sixtus IV. Taking up the programme of these earlier works, they focus upon events from the Bible that legitimise the papal Church (whereas Michelangelo's ceiling frescos form a world in themselves). The Medici pope instructed that the borders should portray scenes from his own life, which he evidently considered comparable to that of St Peter. But if the tapestries were intended as papal propaganda, their subjects were nevertheless taken from the Gospels and the Acts of the Apostles, and it is from this higher perspective that Raphael conceived his designs. The events in the main pictures are magnificently self-contained, free from anachronisms and personal references. The apostles act with a powerful, unstudied pathos, harmoniously set amongst massive works of architecture or within gentle landscapes, with subsidiary details rendered with the exquisiteness of a still life. Raphael's prime focus falls once again upon the interaction between the characters. The impact of Jesus the

St Paul Preaching to the Athenians, 1515/16
Tempera on heavy paper, 390 x 440 cm
London, Victoria and Albert Museum

The tapestries woven from Raphael's cartoons were destined for the presbytery in the Sistine Chapel. The last tapestry of the St Paul series, however, hung in the lay area: the preacher addressed his congregation.

man upon the disciples has seldom been so convincingly rendered with such simple means as in *The Miraculous Draught of Fishes* (p. 52 below) and in *The Donation of the Keys* ("Feed my sheep", p. 52 above).

Raphael took some eighteen months to produce the ten cartoons, which measured an average 3.5 x 5 m – an astonishing feat in purely physical terms alone. They are painted – largely by Raphael himself, according to present findings – in tempera on paper, but in mirror image to the finished tapestries since the designs were reversed during the weaving process. This took place in the tapestry workshop of Pieter van Aelst in Brussels, where in 1520 Albrecht Dürer is supposed to have seen the cartoons and drawn inspiration for his *Four Apostles* from them. (In 1515 Raphael had already sent a drawing by one of his workshop assistants to Dürer in Nuremberg, in order to "show his hand", as Dürer noted on the sheet.) In 1519 the first seven tapestries arrived back in Rome

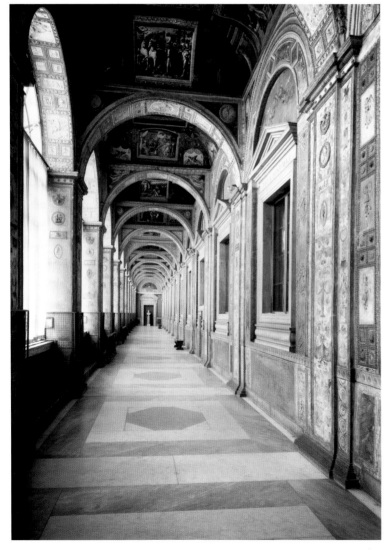

The Raphael loggias, 1513–1519
Rome, Palazzo Vaticano

The architecture, stucco reliefs and fresco decoration of Raphael's loggia were, according to a letter by Castiglione, "perhaps the most beautiful thing Rome has seen since antiquity".

PAGE 55:
The loggietta in Cardinal Bibbiena's apartments, 1516
Rome, Palazzo Vaticano

In the company of Giorgione's pupil Giovanni da Udine, Raphael studied the half-buried rooms ("grottoes") of Nero's Domus Aurea. Giovanni became his specialist for "grotesque" decoration; he also recreated the stucco and wall-painting techniques of antiquity.

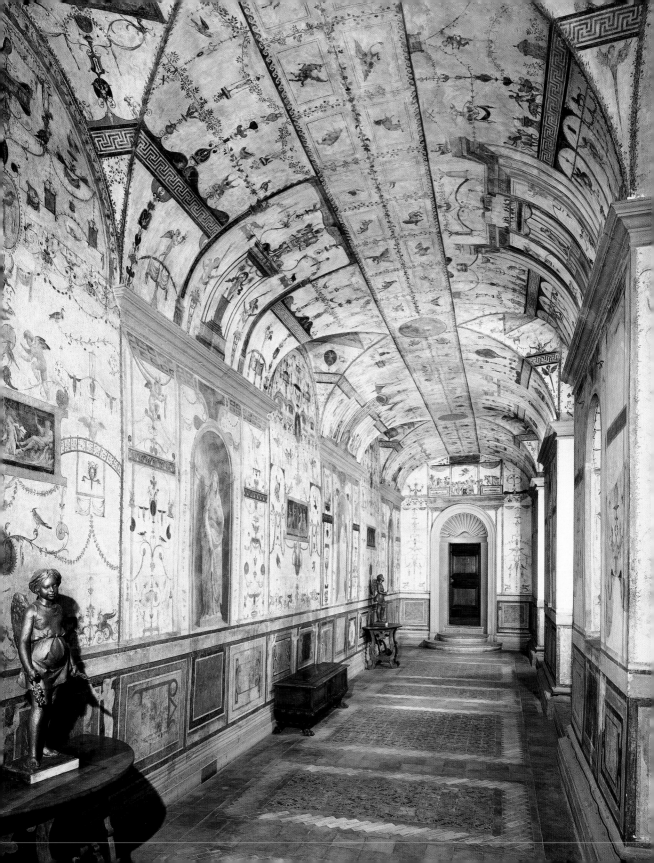

Perin del Vaga and Raffaellino del Colle (?)
The Baptism of Christ, 1517/1519
Fresco, 172 cm wide (max.)
Rome, Palazzo Vaticano

Raphael provided sketches and designs for the
decoration of the loggia, which were then
worked up and finally executed in fresco by
Gianfrancesco Penni and Giulio Romano,
assisted by a large number of other young
painters.

The *stufetta* (bathroom) in Cardinal Bibbiena's
apartments, 1516
Rome, Palazzo Vaticano

The Prophet Isaiah, c. 1512/13
Fresco, 250 x 155 cm
Rome, S. Agostino

The Hebrew scroll contains the words "Open
ye the gates, that the righteous nation which
keepeth the truth may enter in" (Isaiah 26,2).
The Greek inscription at the top of the painting
names the donor, papal protonotary Jean Goritz
of Luxemburg.

and were hung in the Sistine Chapel. The complete series is today housed in the
Vatican Pinacoteca; in 1983, to mark the 500th anniversary of Raphael's birth,
they were displayed in their original location in the Sistine Chapel for several
weeks.

After the cartoons, Raphael and his workshop went on to paint a great deal
more in the Vatican Palace. In the last and biggest room of the Stanze, the Sala di
Costantino, they created a cycle of frescos on the life of Constantine the Great,
including the gigantic bloodbath of the *Battle of Pons Milvius,* whose execution
dragged on until 1524. Against the adjoining exterior façade of the papal apart-
ments, facing the city, Raphael built a loggia (p. 54), which he had decorated
with grotesques in the manner of Nero's Domus Aurea ("Golden House"). For
the loggia's 13 vaults he designed a series of 52 biblical scenes (p. 56 above),
which extend from the *Creation of the World* to the *Last Supper* and were ad-
mired as "Raphael's Bible" (the counterpart to Michelangelo's on the Sistine ceil-
ing). One storey higher lay the apartments of Cardinal Bibbiena (Bernardo
Dovizi), famous as a diplomat, humanist and writer of comedies and a close
friend of Raphael. The artist built and decorated a separate *loggietta* for him
(p. 55) and also decorated his bathroom, the so-called *stufetta*, with mytholo-
gical love scenes executed in antique encaustic (p. 56 left).

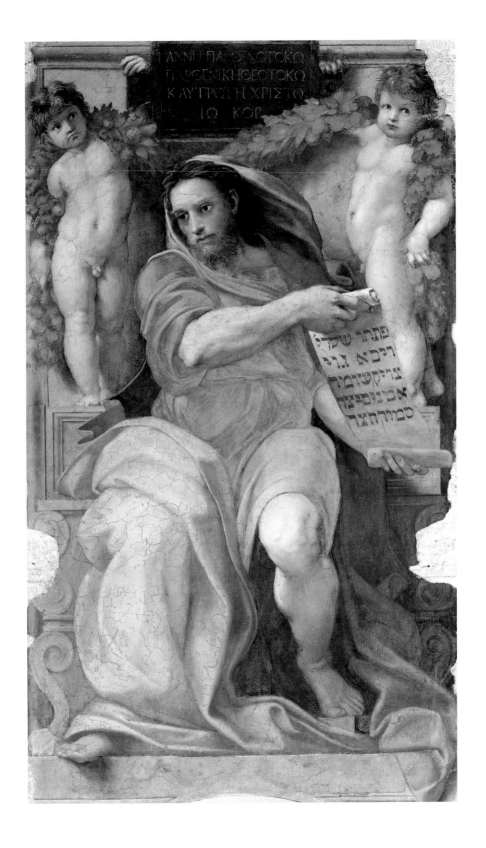

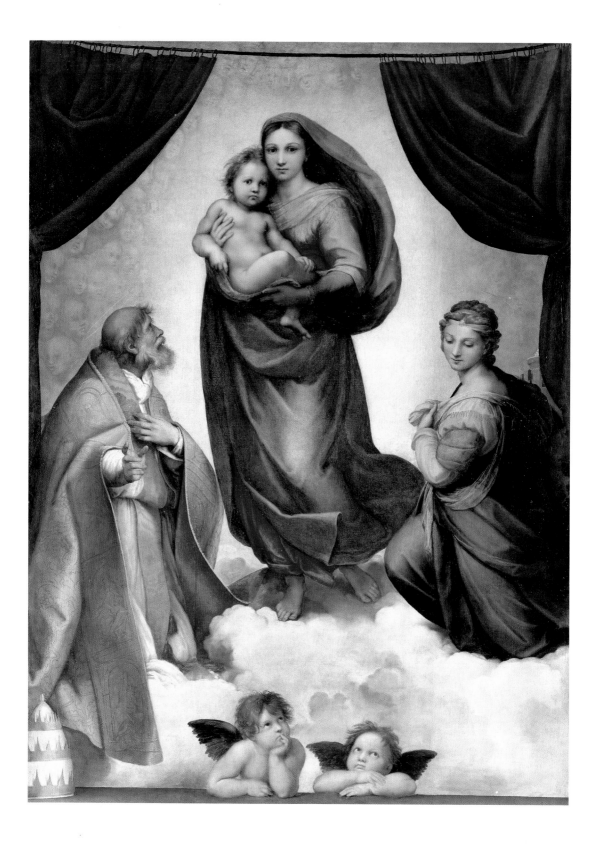

The large altarpieces

The altarpiece – one of the supreme assignments of Christian painting – was something that occupied Raphael from the start of his career to the last days of his life. He quickly learned how to work within the magnificent framework of Umbrian tradition; his Florentine years saw him striving to go beyond it. In Rome he left all the bounds of convention behind him and elevated every subject confronting him to a new spiritual level. He thereby laid the foundations for the altarpiece painting of the Catholic Counter-Reformation. Naturally he needed pause for breath: he produced no altarpieces while he was working on the Stanza della Segnatura. The Stanza d'Eliodoro, on the other hand, proved a fertile point in time: around 1512/13 Raphael painted his three great Madonna altarpieces, the *Madonna del Pesce* (p. 59), *Madonna di Foligno* (p. 60) and *Sistine Madonna* (p. 58), and at the same time the loveliest of all his smaller Madonna paintings, the *Madonna di Loreto, Madonna della Sedia* (p. 33) and *Madonna della Tenda*. The period of the *Fire in the Borgo* also produced *St Cecilia* (p. 61), while the *Spasimo di Sicilia* (p. 65) ties in with the Tapestry Cartoons. The series concludes with the *Transfiguration* (p. 66), which reflects Raphael's interest in literary and art theory in this final phase of his life. Only one of these pictures, the *Sistine Madonna,* was a papal commission; all the rest were executed for private clients. They are nevertheless largely by the hand of Raphael alone; only in isolated cases was his workshop also involved.

The *Madonna del Pesce* (*Madonna with the Fish*) owes its name to the Apocrypha story of the young Tobias who, escorted on a journey by the archangel Raphael, catches a fish and heals his blind father with its gall. It was a popular subject of paintings commissioned to commend sons of rank to the protection of God as they came of age. Whether this is relevant here, we do not know; from a theological point of view, the motif can be understood as "the archangel as accompaniment to the revelation of God" (Eva Krems). The painting, which may not be entirely by Raphael alone, follows the lines of a Virgin enthroned with saints, but its confidently asymmetrical composition demonstrates the freedom with which Raphael now approaches traditional formats. Tobias and the angel present themselves to the Infant Christ, who welcomes them with an expansive, quietly dignified gesture. The Virgin, in the proud pose of Michelangelo's *Delphic Sibyl,* does not need to hold him, but simply supports him on her lap. The Child reaches with his left hand into the book held by St Jerome, whose eyes, serious

Madonna with the Fish (Madonna del Pesce), c. 1512/1514
Oil on panel, 215 x 158 cm
Madrid, Museo del Prado

The altarpiece was commissioned by the Neapolitan nobleman Giambattista del Doce; it hung in his family chapel in S. Domenico Maggiore in Naples until appropriated by a Spanish viceroy.

The Sistine Madonna, c. 1513
Oil on canvas, 265 x 196 cm
Dresden, Staatliche Museen, Gemäldegalerie Alte Meister

SS Sixtus and Barbara, who accompany the vision of the Virgin, are the patron saints of the Benedictine church in Piacenza for which the painting was intended.

Madonna di Foligno, 1512
Oil on canvas, transferred from panel,
320 x 194 cm
Rome, Pinacoteca Vaticana

In 1565 donor Sigismondo de' Conti's niece re-
moved the painting to the convent in Foligno of
which she was abbess. From there it was taken to
Paris under Napoleon and in 1816 returned to
the Vatican.

and wearied from reading, rest on the angel. His solid figure provides a natural
counterweight to the flow of movement that unites the other figures and also in-
corporates the curtain draped to the side. All this is internally motivated and un-
folds logically and with the calm that one often admires in Venetian altarpieces
(such as those by Titian).

The *Madonna di Foligno* was painted for the high altar of the Franciscan
church of S. Maria in Aracoeli on the Roman Capitol, built over the site where
(according to the medieval *Mirabilia Urbis Romae*) Emperor Augustus beheld a
vision in the sky, in which an overwhelmingly beautiful Virgin and Child ap-
peared within a luminous golden disc above an altar. It is this vision that Raphael
portrays, but once again in the manner of a Virgin enthroned (i.e. physically

St Cecilia, 1514/15
Oil on canvas, transferred from panel,
238 x 150 cm
Bologna, Pinacoteca Nazionale

"Five saints next each other, none of whom we
know, but whose existence is so perfect that one
wishes the painting would endure for all etern-
ity, even after one is long gone." (Goethe, diary
of his *Italian Journey*)

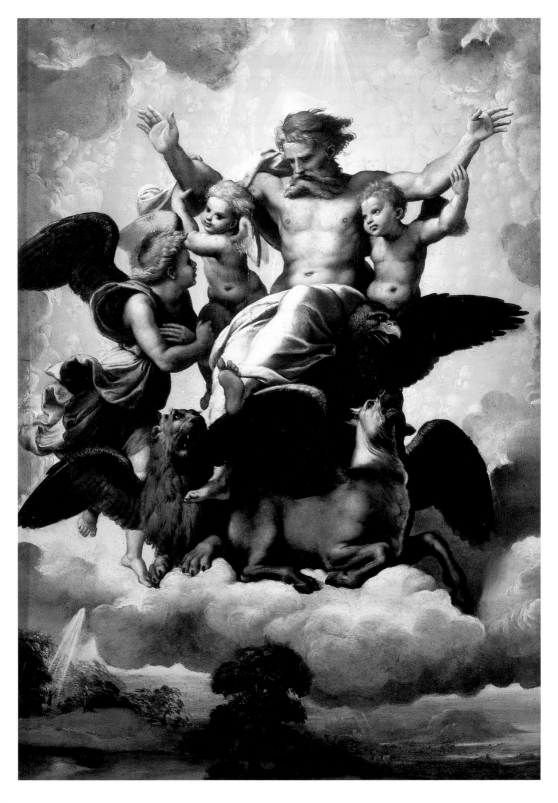

present) with saints. The painting was probably commissioned by donor Sigis-
mondo de' Conti, papal secretary to Julius II and praefect of the Guild of St Pe-
ter's. He died in February 1512 at the age of 80, while Raphael's picture was prob-
ably still in process, and was buried in the choir of the church.

The co-existence within one composition of divine and earthly figures is a
problem that Raphael tackles here with the means of a painterly realism that ex-
tends to all the constituent components, just as he had attempted in the frescos
of the Vatican Stanze. The Virgin indeed appears in heaven, but the atmosphere
around her, composed of angelic putti at the top, passes lower down into an en-
tirely real storm cloud. It is part of a landscape of great poetic beauty, such as
found in the Venetian and Ferrarese painting of the day. When the painting was
cleaned in the 1950s, its surprisingly fresh palette, rich in contrasts, was restored.
Against the gentle green of the landscape behind, Conti's red robes provide both
contrast and mediation. The crisp ultramarine of the clouds makes the solar disc
around the Virgin appear even more radiant. The nature of the light effect over
the rooftops of the small village is unclear; it is connected with some sort of cata-
strophe in Foligno, during which Conti's house was miraculously spared or saved,
in devout thanks for which he is thought to have commissioned the altarpiece.

The Virgin herself is the same size and just as present as the men below:
St John, the sombre preacher in the wilderness, St Francis, who looks up ador-
ingly at the Infant Christ as he shows him the Cross (making him the father of
generations of ecstatic St Francis figures), and St Jerome with the silver beard
commending the donor to the Virgin. Sigismondo's upturned eyes are cloudy
and unseeing, his face a ghostly white; he seems already dead. The tablet held up
by the putto is empty and was most likely intended to remain so; it probably
stands for "the transitory state of the soul that has already departed the body but
not yet reached Heaven" (A. Tönnesmann). There is something comforting
about the physical proximity of the Virgin and saints; one has the feeling, look-
ing at Raphael's painting, that Conti must have died happy.

The *Sistine Madonna* is roughly contemporary with the *Madonna di Foligno;*
both paintings are intended for high altars and their iconography is or appears to
be largely identical: the Virgin and Child with saints. But the role of the *Sistine
Madonna* was very different, and Raphael came up with an entirely new solution.
Commissioned by Julius II, the altarpiece was intended for S. Sisto in Piacenza,
the burial place of Pope Sixtus II, whom Julius' uncle Sixtus IV had elected pat-
ron saint of the house of della Rovere. The painting remained in place until 1754.
Its path to world fame began with its purchase by the king of Saxony; in Dresden
it became the icon of the museum culture of the 19th century. But its removal
from the choir of S. Sisto left only its atmospheric value intact; out of its litur-
gical context, its deeper message was lost.

This message is not easy to understand. Julius II's veneration of the Virgin is
well known and explains the choice of the Madonna as the main figure. The saints
serve as her companions (and represent the person of the donor, who thereby to
a certain extent commends himself). But the pope's theological thoughts repeat-
edly circled, as we know and as the Vatican Stanze demonstrate (*Disputa, Mass
at Bolsena*), around the central tenet of the Catholic faith: the real presence of
Christ in the Eucharist. His Piacenza donation can also be viewed in this light:
the Virgin and Child are intended to inspire participants in the mass to a "con-
templation of Christ's presence in the experience of the Most High" (M. Schwarz).
The pointing gesture by the pope, and the dejected expression of the Child and
the putto in the left-hand foreground, may be addressed at a Crucifixion that (as

The Vision of Ezekiel, c. 1518
Oil on panel, 40 x 30 cm
Florence, Galleria Palatina

The prophet's vision is described in the Book of
Ezekiel, 1–2.

Christ Falls on the Way to Calvary, 1516/17
Oil on canvas, 318 x 229 cm
Madrid, Museo del Prado

The painting acquired its more familiar name,
Lo Spasimo di Sicilia, after it was purchased by
Philip IV in 1622 and taken to Spain.

common in those days) hung above the rood screen opposite the altar. Raphael's ability to make the invisible visible is demonstrated here, too: not in the sense of making a vision concrete, as in the *Madonna di Foligno*, but in maintaining the fiction of the presence of the Virgin at the mass. Since everything – from the arrangement of the figures, the choice of palette and the handling of the light right up to the staging of the whole behind a curtain and parapet – is subordinate to this end, everything also appears very simple. Never before and never again did Raphael achieve such happy coherence in so large a painting.

St Cecilia was commissioned by a private donor, a Bolognese woman of rank, who had been presented with a relic of the saint by the papal legate and built a chapel dedicated to her name. Raphael's altarpiece depicts the key event in Cecilia's life. The daughter of a Roman patrician, she is forced into marriage by her father. But during the wedding service, she hears heavenly voices, while the music being performed by the players sounds to her as if it came from broken instruments. The action is thus taking place solely at an inner level, and for this very reason nothing must be allowed to happen externally. This explains the apparently conventional, almost boring layout, which sees the four accompanying saints (Paul and John the Evangelist on the left, Augustine and Mary Magdalene on the right) grouped around Cecilia in a totally disconnected fashion. In the antithetical nature of their characters they strike a note as dissonant as the damaged instruments on the ground. It is in the vertical that the most important emphasis lies: calm and confident in her faith, the saint (whose features may resemble those of the donor) lifts her eyes to the singing angels whom only she can see and who appear only at the upper edge of the painting. Their celestially pale, almost transparent colouring anticipates that of the upper zone of the *Transfiguration*. The palette employed for the standing figures is earthly in substance, with a wealth of nuance that recalls *The Fire in the Borgo.* As in the fresco, the female figure on the right-hand edge of the painting, with her greyish pink draperies and a veil covering her hair, is a work of particular painterly bravura.

Lo Spasimo di Sicilia takes its name from the monastery in Palermo for which it was painted – S. Maria dello spasimo, the Virgin wracked with grief. The story of its passage to Sicily reads like that of a miracle-working icon: following a storm at sea, the ship sank and both crew and cargo were lost. The painting, however, was washed up undamaged onto the beach near Genoa, from where – after the intervention of the pope – it was eventually sent on to Palermo. The painting shows the moment at which Jesus collapses under the weight of the cross on the way to Golgotha; his anguished mother has to watch his suffering. The multi-figure scene takes place, like the *Entombment* in the Baglioni altarpiece (p. 25), against the backdrop of Calvary hill, and as in the earlier panel Raphael grapples once again with the problem of combining a biblical narrative with heroic action. Subsidiary figures such as the soldier drawn up to full height in the left-hand foreground, and Simon of Cyrene, reaching with a powerful movement for the cross, threaten to overwrite the mother-son theme. The kneeling young woman supporting the Virgin also cites the Baglioni altarpiece. It is almost as if Raphael wants to take up one more time a theme he feels he has not quite mastered. Although the painting, today in poor condition, is documented as having been executed by Raphael's pupils, numerous details are of great beauty, particularly in the group of the three Marys. Vasari, who hadn't seen the picture, describes it as "a marvellous work of art"; once set up in Palermo, it came to enjoy "more fame and reputation than Mount Etna itself".

Although not an altarpiece, mention must be made here of a painting small

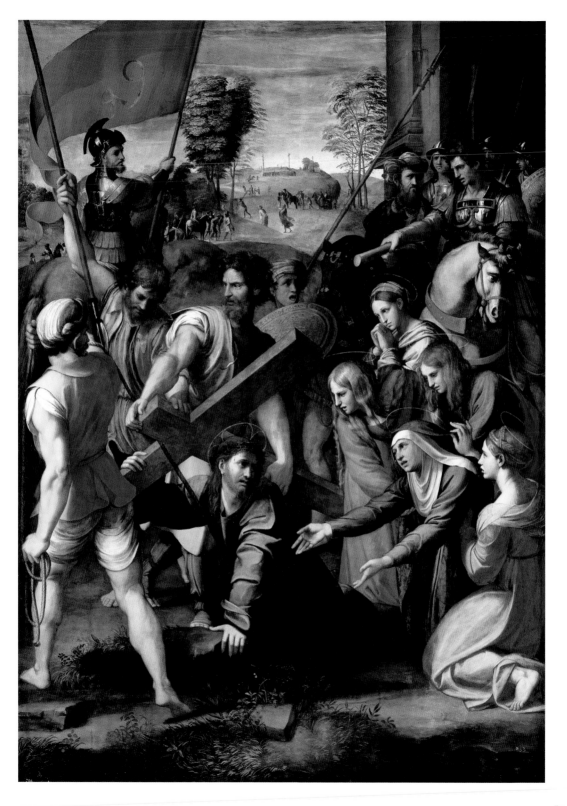

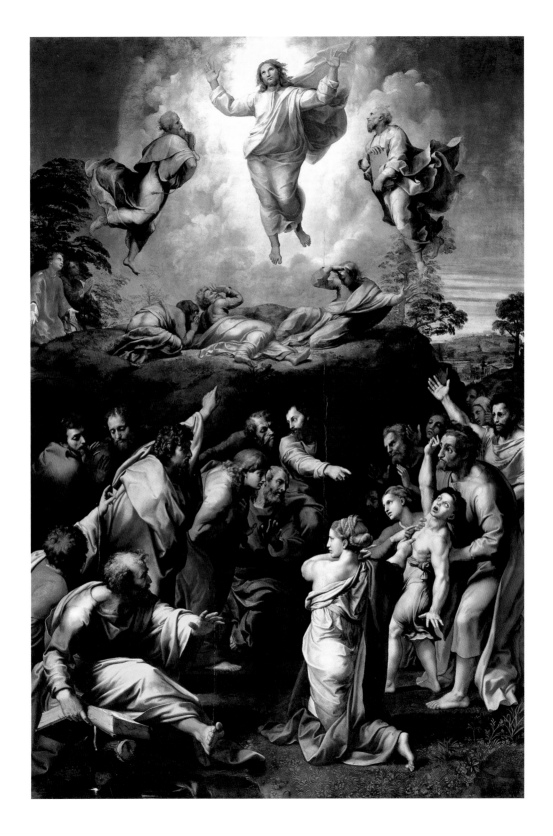

in dimensions but grandiose in its invention: *The Vision of Ezekiel* (p. 62). There appeared to the prophet a vision of God the Father carried by an eagle and accompanied by an angel, a lion and an ox (the symbols of the four Evangelists). God's gesture of blessing with two raised arms is taken from an antique Jupiter sarcophagus. With a bold stroke Raphael has turned reality on its head: the pictorial space is filled almost entirely by the celestial vision, seen in three-dimensional close-up; only at the bottom do we glimpse a fleetingly drawn stretch of earthly landscape. There, in a burst of light piercing the clouds and overwhelmed by the grandeur of God, stands the tiny figure of the prophet.

The commission for *The Transfiguration* came from Giulio de' Medici, cousin of Leo X and himself later Pope Clemens VII. As archbishop of Narbonne in southern France, he wanted to donate an altarpiece to its cathedral. He also commissioned a second painting of the same size from Sebastiano del Piombo, who was assisted in his design by Raphael's eternal rival Michelangelo. Sebastiano was to portray the Raising of Lazarus, Raphael the Transfiguration of Christ, in which the Saviour, accompanied by Moses and Elijah, appears to James, Peter and John in a blaze of light. Sebastiano's picture was completed after two years, in 1519, but Raphael had meanwhile been struck by (or agreed to) a new idea. He combined the Transfiguration with the episode that follows it in the Gospels, in which the disciples try in vain to cure a possessed boy. Only Jesus, upon his return from the mountain, will achieve the miracle. This allowed for more action than the Transfiguration scene alone and furthermore, like the Raising of Lazarus, invited associations with the family name of Medici ("doctors"). Upon Raphael's death in April 1520 the massive panel must have been as good as finished. It stood in his studio at the head of his deathbed and was then put on display for six days in the Vatican in company with Sebastiano's *Lazarus*. The admiration it attracted knew no bounds. There was no longer any thought of sending the painting to far-off Narbonne; it went first to S. Pietro in Montorio in Rome and later, via various avenues, to the Vatican.

The Transfiguration is Raphael's last and definitive work. The division of the pictorial plane into two zones, heaven and earth, had preoccupied Raphael since his early altarpieces (*Coronation of the Virgin*), and the confrontation of two groups within the lower pictorial zone can also be traced right back to his early work (*Marriage of the Virgin, Entombment*). All the problems of painting – light, colour, modelling – are resolved. Contrasting with the supernatural brilliance of Christ is the warmth of the dawn in the right-hand landscape and the moonlight in the lower scene (the boy is a lunatic); the sharp chiaroscuro in the foreground accentuates the dramatic gestures and faces of the apostles (still traceable to Leonardo). Divine revelation and human action, calm and confusion, come face to face and in so doing heighten each other. Thus it seems as if Raphael – consciously or unconsciously – is here once again trying to condense everything that he has ever striven for and achieved into one last, definitive synthesis. Could it succeed? No modern viewer is capable of comprehending the work in its totality, let alone appreciate the wealth of references that the latest research has uncovered within it. The enduring impression remains the transfigured Christ, in His power and glory the equal of Michelangelo's God the Father on the Sistine ceiling. The decision to portray Christ floating in mid-air was – as the drawings show – taken at a later stage in the design process and undoubtedly not without a great deal of thought. It represents a "poetic amplification" (R. Preimesberger) of St Matthew's text: "Jesus… was transfigured before them, and his face did shine as the sun, and his raiment was white as the light."

The Transfiguration, 1518/1520
Oil on panel, 405 x 278 cm
Rome, Pinacoteca Vaticana

The stylistic tension between the two zones of the painting was for a long time put down to its completion by assistants after Raphael's death. The restoration carried out in the 1970s has confirmed, however, that the work we see today was executed by Raphael himself.

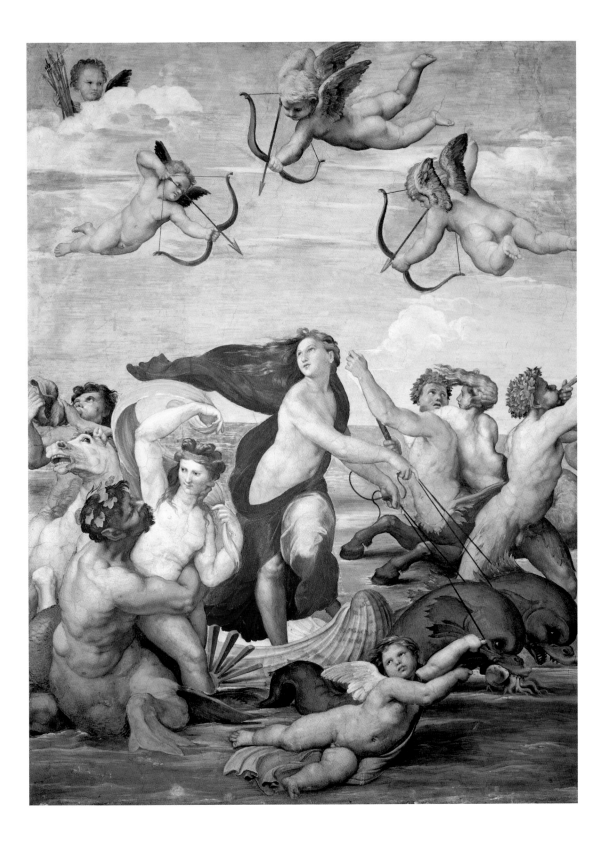

The patron: Agostino Chigi

Art and wealth belong together – this was a conviction shared by all famous artists of the day and one that Raphael voiced on numerous occasions: one might have learned how to imitate the style of imperial Roman architecture, but not the solidity of its construction and the lavishness of its decoration. And so it was only logical that he should form a close relationship with the richest man in the city. It would prove fruitful for both. Agostino Chigi – also dubbed "il Magnifico", the Magnificent, like the great Lorenzo de' Medici – came from a Sienese family of merchants and bankers. He owed his rise to a strict monopolism that ensured him, amongst other things, a dominant position in the alum market (the mineral alum being a key ingredient in clothmaking, the leading industry of Renaissance Italy). He made himself indispensable to Julius II both as a financier and as a diplomat: he was personally involved in the setting up of the league between the Holy See and Republic of Venice (an arrangement that would also further his business interests). Although he also bought his way into Curial offices, in papal Rome he nevertheless remained a singular and undoubtedly glamorous figure. An attempt to marry a Gonzaga marchioness – and thereby secure himself a place in the Italian aristocracy – did not come off. Shortly before his death, under pressure from the Pope, he married instead his mistress Francesca Ordeaschi, whom he had brought back from Venice as a young girl of humble birth eight years previously. Chigi died at the age of 54 on 11 April 1520, five days after Raphael. Most of his immense fortune he left not to his widow, but to their children (now legitimised by their marriage), who rapidly squandered it.

As a generous patron of literature, science and the arts, Chigi enjoyed in Rome the reputation of a new Augustus. Since he himself was active in none of these fields, it is hard to draw up an intellectual profile of the man, or to form an opinion of his character. Nor do we possess any portraits of the person who employed two of the greatest portrait painters of the epoch. He exerted an enduring influence on the art of the Roman High Renaissance not as a buyer and collector (although he collected antiques like all the leading members of Roman society) or as a private donor, but rather as a patron on a princely scale, who engaged the services of artists such as Peruzzi, Sodoma, del Piombo and Raphael in order to document his status. His palatial villa on the banks of the Tiber (which later became known as the Villa Farnesina) and his burial chapel in S. Maria del Popolo testify to the scale of his ambition.

Agostino Chigi's villa on the banks of the Tiber (Villa Farnesina)
Rome, Via della Lungara

Built by Baldassare Peruzzi between 1508 and 1511, Chigi's "Suburbanum" became the prototype of countless middle-class suburban villas of the modern age. At the end of the 16th century the plot was acquired by the Farnese.

Galatea, 1511
Fresco, 295 x 225 cm
Rome, Villa Farnesina

The seemingly chaotic composition is carefully balanced: in one of the amorous couples, it is he who embraces her, in the other she him; here she raises her right arm, there he his left; here we see him from the right and her from the front, there him from the left and her from the rear. Galatea alone stands upright and is visible in her entirety.

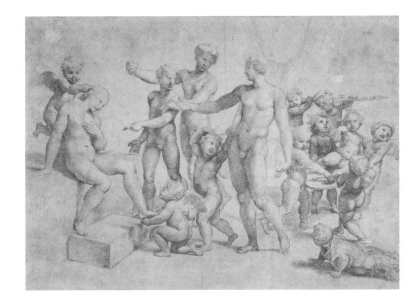

The Marriage of Alexander the Great to Roxane, c. 1517
Red chalk over metal stylus on paper,
22.8 x 31.6 cm
Vienna, Graphische Sammlung Albertina,
inv. no. 17634

Design for the fresco in Agostino Chigi's bedroom, later executed by Sodoma in a different form.

Edouard Manet
Déjeuner sur l'herbe, 1863
Oil on canvas, 208 x 264,5 cm
Paris, Musée d'Orsay

Giorgione's (or Titian's) *Pastoral Concert* in the Louvre and Raimondi's engraving provided the starting-points for Manet's famous canvas, exhibited in Paris in 1863 in the first Salon des Refusés.

Chigi's residence on the Tiber (p. 69) had just been completed when he sought the hand of Margarita Gonzaga in Mantua. A contemporary poem describes how Venus, making a tour of the world, decides to make the villa her new palace. Its literary source was Poliziano's *Giostra* (joust), which celebrated Cupid's victory over the young Giuliano de' Medici, in love with the beautiful Simonetta Vespucci. The palace of Venus on Cyprus described in Poliziano's verses is decorated with pairs of lovers from classical antiquity, including Polyphemus and Galatea, whom Chigi now had painted in his own palace, in the loggia facing the Tiber. The one-eyed giant – who is seen sitting, as in Poliziano, beneath a maple tree as he tries to win the heart of the sea nymph with his singing – is the work of the Venetian artist Sebastiano del Piombo, who had followed Chigi to Rome and had already decorated the lunettes in the same loggia. But the *Galatea* (p. 68) in the adjacent field was painted by Raphael. He does not take up the background surroundings established by Sebastiano, but creates an autonomous picture which is also far removed from its literary source. Thus the narrative acquires a double horizon, and Polyphemus finds himself in the role of a painted observer, rather like the pope in *The Expulsion of Heliodorus* (pp. 46–47). Raphael formulates his composition in the antithetical terms recommended by Leonardo: the members of Galatea's train give themselves up to the pleasures of love, while she herself looks heavenward, not unlike *St Catherine* (p. 26). The love songs of her monstrous suitor fail to move her, just as she has yet to be pierced by the darts of the amoretti fluttering in the skies above her. Was the fresco intended as a homage to the Gonzaga daughter whom Chigi was at that time hoping would become mistress of his house? It was evidently improvised at speed and both drawing and painting reveal a number of errors. But the virginal blonde has turned the heads of Raphael fans of all epochs and inspired rapturous comparisons no less than imitations – even Truman Capote felt reminded of her at the sight of Marilyn Monroe. For Raphael, *Galatea* was his first step into the world of pagan mythology – a world that would lend powerful wing to his imagination over the following years. The reproduction of his works via graphic

media, in particular engraving, ensured that his inventions reached a wider public (p. 71 below); indeed, they would continue to influence artists right up to the 19th and 20th centuries (p. 70 below and p. 71 above).

Chigi's marriage to Francesca Ordeaschi, celebrated in 1519, was preceded by a fresh round of wall-painting in his palace. For his bedroom, Chigi chose the marriage of Alexander the Great to Roxane, the princess he had captured in battle. Although the fresco was executed by Sodoma, Raphael appears to have supplied designs (p. 70). The entrance loggia was decorated with a fresco cycle based on the story of Cupid and Psyche told by Apuleius in *The Golden Ass.* His choice of subject shows how Chigi perceived his role as husband: Roxane waits submissively for the ruler who will elevate her to his status, while Psyche is led by Mercury, the god of merchants, up to Olympus, where she is to be granted a place at the table of the immortals. These might be interpreted as the triumph of love over class difference – this is the mood running through Raphael's frescos, at least. For this commission, unlike the *Galatea*, the master called in his workshop. Giovanni da Udine, a specialist in the painting of vegetation, transformed the loggia into a garden pergola. The large assembly of the gods on the ceiling of the vault is painted on imitation canvas awnings (*vela*). Blue skies filled with birds and cupids open up in the spandrels beneath and provide the backdrop to the celestial episodes in Psyche's story; the scenes set on earth were perhaps destined for the lunettes or the walls. Although the quality of the workshop execution was criticized even in its own day, not all of it is poor; there are some

Pablo Picasso after Manet
Déjeuner sur l'herbe
Vauvenargues, 3 March to 20 August 1960
Oil on canvas, 129 x 195 cm
Paris, Musée Picasso

Marcantonio Raimondi after Raphael
The Judgement of Paris, 1514/16
Copper engraving, 29.1 x 44.2 cm

The most famous of the mythological compositions that Raphael designed for engraver Marcantonio Raimondi served as a source for countless artists. The group of three gods reclining on the right-hand edge of the picture would later resurface in a most unexpected context.

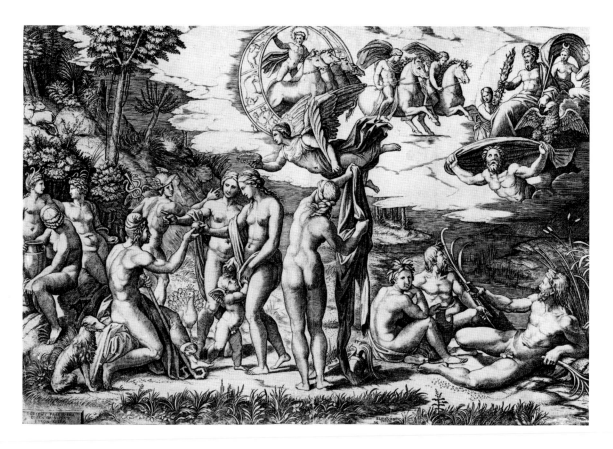

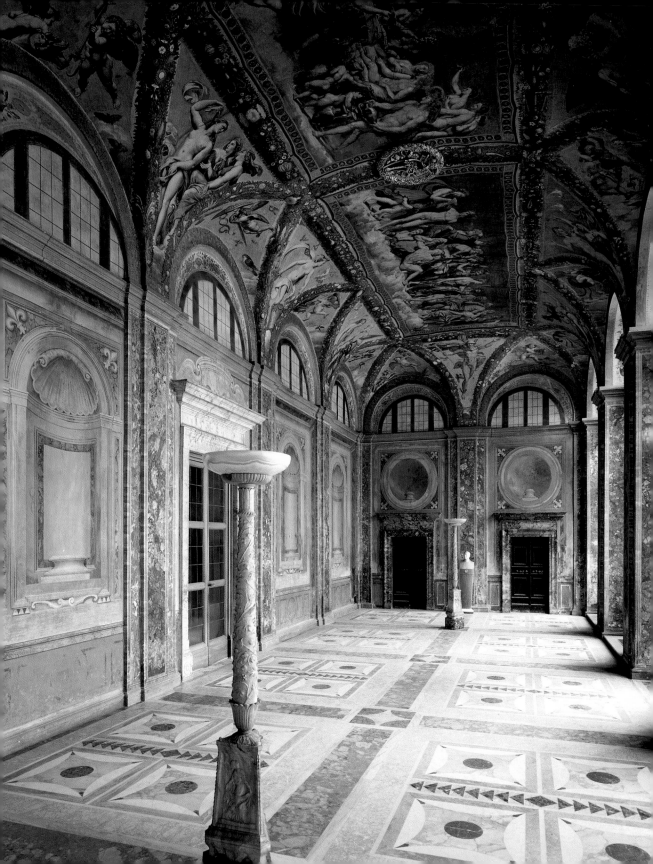

The Three Graces, study for the **Wedding Feast**
in the vault of the Loggia di Psiche, 1517/19
Red chalk on paper, 20.3 x 26 cm
Windsor Castle, The Royal Collection, RL 12754

Three poses by the same model, rapidly sketched,
produce a naturally animated group.

Loggia di Psiche in the Villa Farnesina, Rome

Giulio Romano probably painted Mercury, Gio-
vanni da Udine the garlands of fruit.

magnificent details, and the preliminary drawings are predominantly Raphael's
own. If Galatea was still a figure of art, Juno, Venus and Ceres are realistic nudes,
part girlish, and part womanly in their divinity. We neither know nor need to
know whether Raphael was the great lover of women that Vasari would have him
be; as a painter of female beauty, he ranks undisputedly amongst the best.

Julius II not only granted Chigi permission to bear the della Rovere oak in his
coat of arms, but also conceded him two chapels in della Rovere family churches.
Chigi entrusted their decoration to Raphael. Of his designs for the chapel in
S. Maria della Pace, only the fresco of the *Four Sibyls* (p. 74) was executed, on the
outer entrance wall. As female figures in draperies, they are related to the Muses
and Sappho on *Parnassus* (p. 39), but the atmosphere here is no longer lyrically
poetic but spiritually charged, the drawing is sharper and the body language
more pointed. Having come so close to Michelangelo's example in the Cardinal
Virtues (p. 42) of the Stanza della Segnatura, Raphael has here distanced himself
once more. His *Sibyls* are portrayed in dialogue, and they are no longer toiling
over a study of the sources, but are listening to the divine guidance that tells
them what to write. The masterly fresco technique and the handling of luminous
colour against a smoky background suggest that the fresco dates from the end of
the Stanza d'Eliodoro years.

The Chigi Chapel in S. Maria del Popolo, in which Chigi is buried, takes the
form of a domed mausoleum placed against the aisle of the church. It thereby
became the prototype of countless family burial chapels in the years that fol-
lowed. Raphael's authorship is here intellectual rather than manual, and incorp-
orates both the decoration of the chapel and its architecture. Like Bramante in
his designs for St Peter's, Raphael took the cupola of the Roman Pantheon and
placed it on a supporting structure of four columns and arches. The opulence of
its decoration in marble, bronze and mosaic had never been seen before, and it
corresponded to the image in people's minds of the buildings of Imperial Rome.

Four Sibyls, 1513/14
Fresco, width 6.15 m
Rome, S. Maria della Pace

Timoteo Viti (?) painted four prophets on the upper part of the wall. Studies by Raphael for a Resurrection of Christ perhaps relate to an altarpiece for the same chapel.

God the Father, the Seven Planets and the Fixed Stars, 1516
Cupola mosaic in the Chigi Chapel
Rome, S. Maria del Popolo

As Michelangelo had done in his story of creation on the Sistine ceiling, so Raphael here presents another magnificent vision of the Ptolemaic, medieval model of the world – a model that Copernicus was already in the process of turning on its head.

Chigi had held the patronage right to the chapel since 1507. It was dedicated to the Virgin of Loreto, whom Chigi particularly venerated and whose cult Julius II expressly encouraged. The history of its construction is complicated, and Raphael's original design was altered somewhat in the 17th century, when the Chigi pope Alexander VII commissioned Gianlorenzo Bernini to make some changes. At the time of Chigi's and Raphael's deaths, the wall cladding, cupola mosaics and statues of Jonah and Elijah were all complete; the altarpiece (a *Nativity of the Virgin*) by Sebastiano del Piombo and the frescos by Francesco Salviati were not completed until 1544. The eight fields in the flattened dome show the seven planets and the fixed stars, kept in motion by angels; God the Father appears in the lantern as Creator of the World (p. 75). The grave pyramids, the sculptures of Jonah and Elijah and the eagle in the frieze can be interpreted as symbols of resurrection. With its mixture of pagan, Neoplatonic and Christian ideas, the Chigi Chapel is intellectually the richest work of Raphael's late phase. It has been plausibly suggested that Chigi's contribution was more than merely financial in nature: "Raphael's chapel in Santa Maria del Popolo shows the most responsive of artists warming to the presence of a profoundly intelligent man." (Ingrid Rowland)

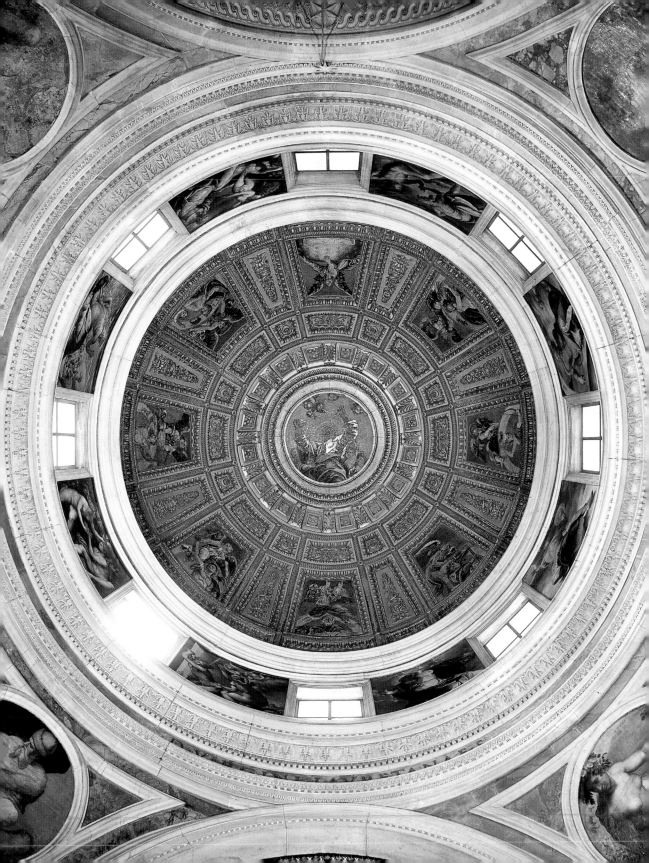

Portraits

Raphael was one of the famous portraitists of his day, yet there is no such thing as a typical Raphael portrait. Almost everyone he painted exudes a different presence, is portrayed in different terms, embodies their own, distinct type. This is undoubtedly characteristic of the society in which Raphael moved, but no other painter made such potent use of the freedom this offered. Even with Titian, it is possible to predict to a certain degree how a sitter will appear in the final portrait; not so with Raphael. It is as if the question of how to capture a truly personal likeness was one that he asked himself afresh with each new client.

With his *Mona Lisa* (p. 77) in Florence, Leonardo had created both a paradigm of modern portrait painting and, at the same time, a facial expression of enigmatic ambiguity. Raphael remained untouched by this, however. Standing in front of his Florentine portraits, one is reminded rather of the great Netherlandish realists than of the world of the Gioconda. However unabashedly Raphael adopts the pose, compositional framework and spatial organization of the Leonardo portrait in his *Lady with the Unicorn* (p. 76), the cool watchfulness in the young woman's gaze is very different. *Angelo* and *Maddalena Doni* (pp. 78 and 79), a prosperous merchant couple, are also entirely of this world. If these two panels distinguish themselves from portraits of other Florentine citizens, it is through their vibrant palette and energetic modelling, and the impression these produce of an almost challenging physical presence. Less accessible are two portraits of anonymous women, who have become known as *La Donna Gravida* (the pregnant woman; p. 81) and *La Muta* (the mute woman). Issuing from both portraits is a slight emotional tension which, because we cannot explain it, is unsettling. Even the very elegantly dressed, magnificently painted *La Muta* has yet to be identified. Her hands are perhaps the most delicate and distinctive that Raphael ever had to paint (but do not bear comparison with those of the *Mona Lisa*, however).

One might have thought that, with his move from Florence to Rome and his entry into the sphere of court art, Raphael's portraits would have to become more ceremonial, more conformist. In fact, it was only here that they assumed their greatest degree of freedom. Raphael painted the portraits of two popes, and we can be certain that, in doing so, he observed all the rules of court protocol. Both paintings nevertheless tell us infinitely more about the person than about the office they represent; only Titian and Velázquez would get so close to a pope

Leonardo da Vinci
Mona Lisa, 1503–1506
Oil on panel, 77 x 53 cm
Paris, Musée du Louvre

The Lady with the Unicorn, c. 1505/06
Oil on canvas, transferred from panel, 65 x 51 cm
Rome, Galleria Borghese

A restoration of 1935 liberated the portrait from its disguise as a St Catherine. The small, heavily overpainted unicorn might also have been a lapdog.

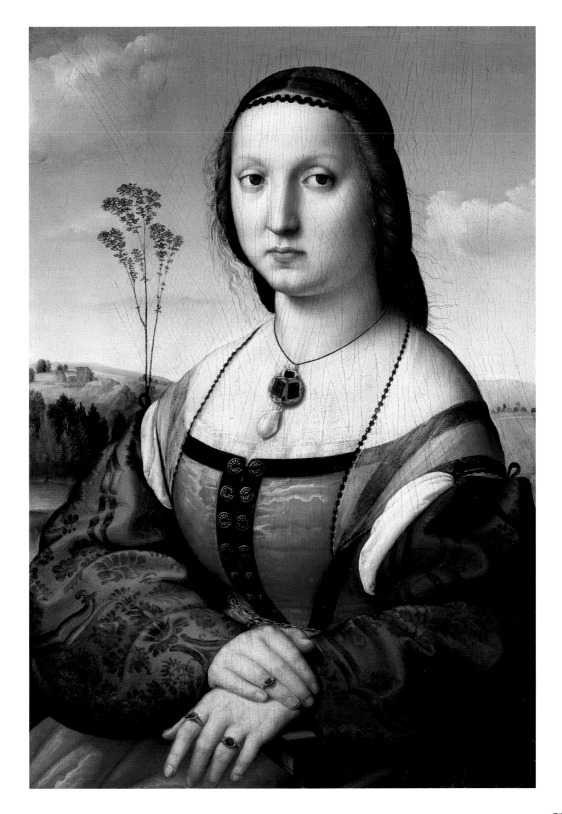

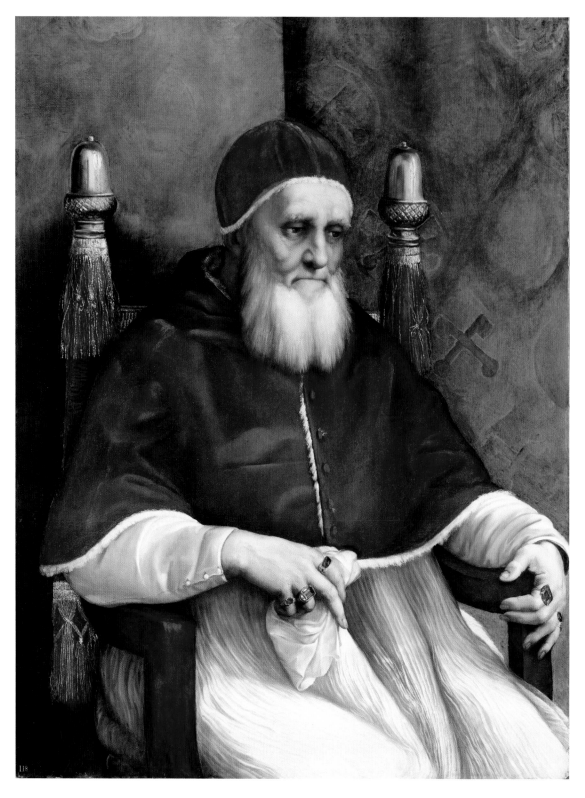

again. The portrait of *Pope Julius II* (p. 80) evidences both respect and empathy, indeed sympathy. It depicts the authoritarian and belligerent della Rovere pope – *il papa terribile* – in his final year of office with his life's work done, but not as a victor. He gazes in front of him; his features still reveal strength of will, courage and magnanimity, but they are relaxed; melancholy nestles in the dark hollows of his eyes. After Julius's death, the portrait was put on display in S. Maria del Popolo, together with the similar-sized *Madonna di Loreto,* and the people of Rome flocked to see, for one last time, the man they had both admired and feared.

In terms of painterly bravura, the portrait of Julius II is if possible surpassed by that of the Medici pope *Leo X* (p. 83) with – as later additions – the two cardinals Giulio de' Medici and Luigi de' Rossi. Four different shades of red, with differing degrees of luminosity, are orchestrated in perfect harmony. The precious items on the table before him are painted with miniature-like precision, and the embroidered damask of his robes and the velvet of his *camauro* (cap), *mozzetta* (cape) and chair are tangibly real. Despite the relatively intimate atmosphere, the pope's pose appears forced, almost rigid; his eyes are turned away from the viewer and do not meet those of his cousin. His face shows a somewhat prepossessing mixture of *bonhomie* and hardness, even cruelty, as indeed the Medici pope on occasion displayed.

Although the majority of Raphael's Roman portraits show figures who moved in Curia and papal court circles, even here the emphasis lies more upon the person than upon their social standing. Some of them remain anonymous, like the fascinating *Portrait of a Cardinal* (p. 82 right) in the Prado (the identification with Francesco Alidosi, murdered in 1511, is pure speculation). The portrait is unsurpassed in its formal simplicity: the masterly silk *mozzetta* forms a pyramid which supports the fine, intelligent, perfectly still face; not even the hands are to be seen. The badly (and probably irreparably) damaged portrait of *Cardinal Alessandro Farnese* (p. 82 left) today in Naples resembles the fresco portrait on the *Justice* wall in the Stanza della Segnatura. It is one of Raphael's earliest portraits in three-quarter figure; the pose and the wonderfully characterful, freely moving hands contribute to the statement made by the whole.

Tommaso "Fedra" Inghirami was one of the most powerful and charismatic preachers in Rome under Julius II. In his younger years, the rotund, pronouncedly cross-eyed man acted in antique plays dug up by humanists. He became famous in the role of Hippolytus in Seneca's *Phaedra* when, during one performance, the set collapsed and he proceeded to improvise a monologue in Latin verse until the damage was repaired. In 1510 Inghirami was appointed praefect of the Vatican library, and it is in this role that Raphael portrays him (p. 84). Dressed in his working clothes, the praefect is seated at his desk, evidently still in the process of formulating an idea before writing it down. Instead of tactfully concealing his squint, Raphael boldly interprets it as an expression of inspiration. The idea of capturing a subject in a fleeting but characteristic moment was new, and was perhaps inspired by the history paintings in the Stanza d'Eliodoro. The result is the opposite of that achieved with a studied, staged setting: the immediate presence of the sitter.

Raphael sent the double portrait of *Andrea Navagero and Agostino Beazzano* (p. 86) to Cardinal Pietro Bembo in Padua. Bembo knew Navagero – a fellow man of letters – and counted him as a friend. The portrait shows two men who have interrupted their conversation to look at us. Their heavy bodies completely fill the pictorial space and there is nothing in the foreground (such as a table or

La Donna Gravida, c. 1507
Oil on panel, 66.8 x 52.7 cm
Florence, Galleria Palatina

The palette is more subtle, the modelling less insistent than in the Doni portraits, but the unknown female sitter is nevertheless absolutely present in all the fullness of her pregnancy. Raphael's portraits are gaining in depth.

PAGE 78:
Angelo Doni, 1506
Oil on panel, 65 x 45.7 cm
Florence, Galleria Palatina

PAGE 79:
Maddalena Doni, 1506
Oil on panel, 65 x 45.8 cm
Florence, Galleria Palatina

Doni was a wealthy Florentine merchant and art collector for whom Michelangelo had painted a famous Madonna tondo, perhaps to mark his marriage to Maddalena Strozzi (1503 or 1504).

PAGE 80:
Pope Julius II, 1512
Oil on panel, 108 x 87 cm
London, The National Gallery

The history of the London painting can be traced back to its original location in S. Maria del Popolo. Florence possesses two early copies, one in the Uffizi and the other (possibly by Titian) in the Galleria Palatina.

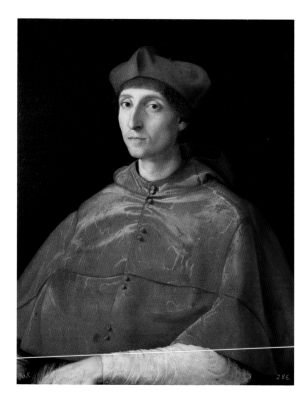

Cardinal Alessandro Farnese, c. 1512
Oil on panel, 132 x 86 cm
Naples, Museo di Capodimonte

The poor condition of the portrait today should not distract us from its magnificent composition.

ABOVE RIGHT:
Portrait of a Cardinal, c. 1510/11
Oil on panel, 79 x 61 cm
Madrid, Museo del Prado

This painting only came to light in the 19th century. While its attribution to Raphael is not disputed, the sitter has no name and his face provides no clues to his identity.

Pope Leo X with Two Cardinals, c. 1517/18
Oil on panel, 155 x 119 cm
Florence, Galleria degli Uffizi

Raphael's painting was dispatched to Florence in 1518 to "represent" the pope at his brother Lorenzo's wedding. In 1524 Andrea del Sarto executed a copy for the Duke of Mantua (today in Naples).

chairs) to distance them from us. The viewer – i.e. Bembo – is thereby made to feel part of their discussion and can almost hear the sound of their voices.

Probably Raphael's most exquisite male portrait is that of *Count Baldassare Castiglione* (p. 85). The diplomat and author of *The Courtier* – the ultimate handbook of courtly conduct in the Renaissance – offers himself as a nobleman, reserved, but with an open countenance and a warmth to his pose. Raphael succeeds in allowing us to sense his respect and gratitude towards his friend and literary mentor, five years his senior, without making the portrait too personal. The palette is restricted to the most sophisticated nuances of grey, black and white, immersed in a vibrant light, while Castiglione's blue eyes shine out from his reddish face. How details rendered with a Holbeinesque precision can coexist within the same frame as a saturated, matt-shimmering painting in matching tones remains Raphael's secret.

The picture of Castiglione also testifies to a distinguishing quality of Raphael's mature portraiture: he paints not just the likeness of his sitters but also the relationship he enjoys with them. Observation is married with personal involvement, different in each case. His portraits are dialogues: this makes them overwhelmingly suggestive, but also – paradoxically enough – creates distance. "The more we study Raphael's portraits the more we must acknowledge that they were not painted for us" (Roger Jones, Nicholas Penny) – especially when we do not know the sitter. This is unfortunately the case above all with Raphael's female portraits, which have come down to us only as *La Donna Gravida, La Muta, La Donna Velata* (the woman with a veil; p. 2) and *La Fornarina* (the baker's daughter; p. 87). These last two arose in Rome, and it has long been wondered if

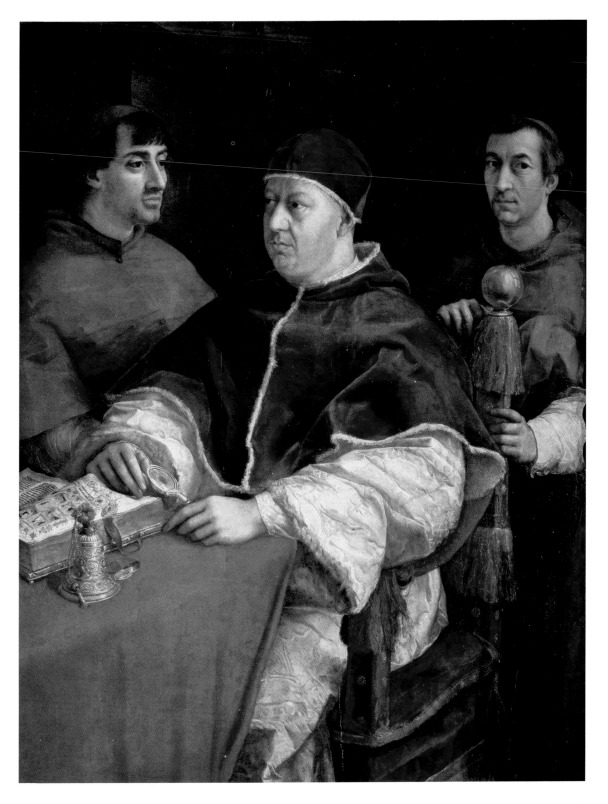

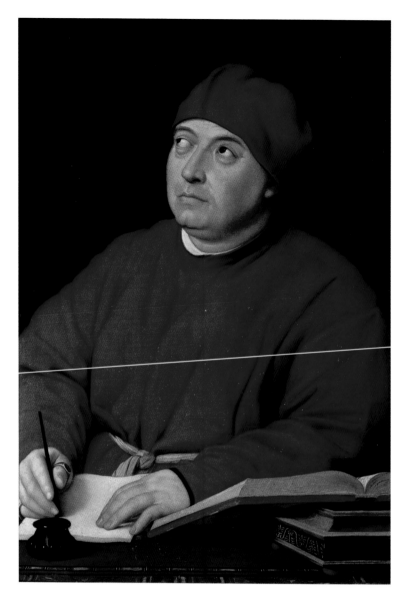

Tommaso Inghirami, c. 1510/11
Oil on panel, 89.5 x 62.3 cm
Florence, Galleria Palatina

A second version of this portrait is in Boston; which of the two is the original remains the subject of dispute.

they depict the same person. Vasari claims that the *Donna Velata* portrays the woman whom Raphael loved right up to his death; her features re-appear in the *Sistine Madonna* (p. 58) and perhaps also in the *Madonna della Sedia* (p. 33). In terms of palette, it is once again a picture of extraordinary sophistication: white, gold, silver and shades of pale ochre harmonize with the exquisite flesh tint. That the spectacular puff of the sleeve might detract from the charm of the face, even-featured but incomparably full of life, does not seem to have worried Raphael.

 La Fornarina's power of attraction is of a different kind, even if certain similarities in the two women's poses and attire demand comparison. Raphael's monogram on the armband testifies both to his authorship and his personal

Count Baldassare Castiglione, 1514/15
Oil on canvas, mounted on panel, 82 x 67 cm
Paris, Musée du Louvre

Raphael's *Castiglione* portrait was copied by Rubens and provided the inspiration behind an etched self-portrait by Rembrandt, in which his arm is resting in front of him.

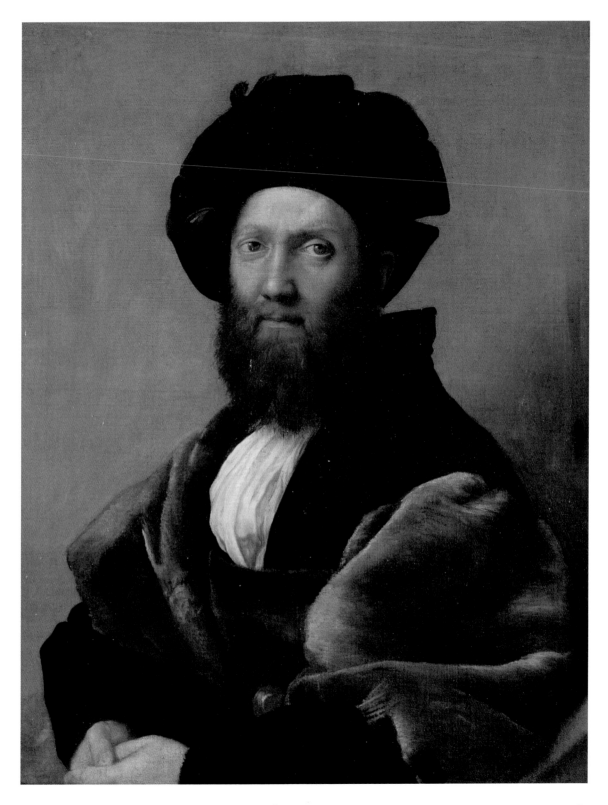

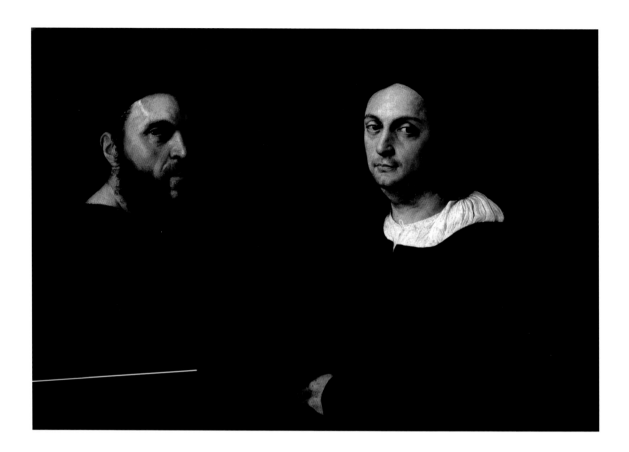

relationship with the model; the panel nevertheless reveals various layers of
paint and differing techniques which suggest that it was completed by someone
else (Giulio Romano?). Whatever the case, it is a work of great power and au-
thenticity. If portraits had a theme, it would here be the latent conflict between
head and body. In particular the veil, held half-heartedly in front of the body,
makes the sitter appear nude rather than naturally naked like of a goddess. The
erotic tension of the picture culminates not in the woman's soft, meltingly
painted body but in her face, smooth as enamel, with its large, dark eyes looking
steadily at the viewer. Its expression is indecipherable. Whereas Leonardo, in his
Mona Lisa, transported a well-known lady of society into the realm of the un-
real, Raphael's all too real but anonymous beloved confronts us with the enigma
of her person. Her identification with the baker's daughter from Trastevere, with
whom Raphael is supposed to have lived while working on Chigi's villa, was
probably only a later attempt to give this strange portrait some sort of name.

Epilogue: "Those fine classical buildings"

On 1 April 1514, a papal breve issued by Leo X appointed Raphael chief architect of the new St Peter's. "What place," he wrote proudly to his uncle Simone Ciarla in Urbino, "is more dignified than St Peter's, the first temple in the world? It is the biggest building site ever seen; the costs will come to a million gold ducats." His name had been put forward by Bramante, who had commenced the rebuilding of St Peter's under Julius II and supervised its progress till his death in March 1514. Bramante's reasoning was plain: Raphael was from Urbino like himself, and although famous as a painter, inexperienced as an architect and hence unlikely to thwart Bramante's own plans for the cathedral with ideas of his own. And he seemed, like the newly-elected pope, young enough to see to the project through to the end. This proved an illusion; both died within just a few years, times changed dramatically, and the St Peter's project got out of everyone's control. Not until the 17th century would the papacy manage to complete it.

To appoint a painter as an architect today strikes us as risky, but in those days it was nothing of the sort. Few of the great architects of the age had enjoyed a specific training in their field. Figural drawing was considered the only skill needed in any of the arts, but anyone designing tombs or altarpieces would naturally also have needed to master an architectural vocabulary. Raphael paid great attention to the architectonic element within his painting from early on (p. 12). His interest in ancient Roman architecture was first aroused in Florence, where its ideals had been championed since Brunelleschi's day (p. 20). His finest architectural drawing – one of the few that survive from his hand – was executed during this period and shows an interior view of the Pantheon, omitting one section of wall (p. 91). Although much perceptive scholarship has gone into proving the opposite, it seems likely that Raphael copied it from an existing book of architectural drawings that he is known to have consulted on other occasions. This would explain why he has made an incorrect addition, something that would not have happened if he had been sketching in situ.

Raphael's practical career as an architect only began in Rome – but then on an imposing scale. For the pope he built the Vatican loggias, for Agostino Chigi the burial chapel in S. Maria del Popolo and the stable block (later destroyed) at Chigi's Tiber villa. He built a series of private palaces for other clients, including one in Florence, and the small church of S. Eligio for the Goldsmiths' Guild in Rome. In the final years of his life he was chiefly engaged on two large-scale

Villa Madama
Rome, Monte Mario

Villa Madama, garden loggia
Rome, Monte Mario
Present condition

The stucco reliefs are by Giovanni da Udine, the frescos by Giulio Romano.

projects, St Peter's (p. 93 above) and the Villa Madama (p. 89) on the slopes of Monte Mario. This latter he designed for Leo X and his cousin Giulio de' Medici, himself well versed in architecture. What links all these buildings is the idea of restoring to papal Rome, as the seat of the Church, the glory of imperial Rome. In the wake of Bramante, who had revived the building style, or *maniera*, of classical antiquity, Raphael sought to imitate the magnificence of their buildings. He aimed to dazzle the eye not just with lavish materials (as in the Chigi chapel) but also with a wealth of architectural divisions. Thus pilasters and half columns, aedicules, blind arches and rusticated blocks, niches and mural fields combine – like the figures in Raphael's late compositions, such as the Vatican tapestries – to form tense, crowded ensembles. A building such as the Palazzo Branconio dell'Aquila (p. 93 below), today vanished, contained "the embodiment of all the forms that Raphael dared to condense into one façade in accordance with the laws of beauty" (J. Burckhardt). Architectural mannerism has its roots here.

In the face of Raphael's architectural production, the question arises as to how much of it is actually his. The concept of authorship is hardly applicable to buildings, but it can certainly be applied to designs. Here we are faced with a problem: the number of design drawings surviving from the hand of Raphael is almost zero. In contrast, we know of many such drawings by architects who worked alongside him. The most important name in this context is that of Antonio da Sangallo the Younger, who trained under Bramante. In 1516 he was appointed second architect on the St Peter's project and assumed overall charge after Raphael's death. Building only got going again after his arrival, and the large number of plans, studies and sketches by his hand suggest that the real design work also fell to him.

The same is true for the most magnificent product of Raphael's architectural imagination, the Villa Madama: we have over a dozen designs from the hand of

Antonio da Sangallo the Younger
Groundplan of Villa Madama, 1519
Pen and red chalk, 60.1 x 125.8 cm
Florence, Galleria degli Uffizi, Gabinetto dei Disegni e delle Stampe, n. 314 A

The plan, on several sheets of paper glued together, shows the project after the final corrections by Raphael and Antonio da Sangallo, on a scale of 1:350, with notes in Sangallo's hand.

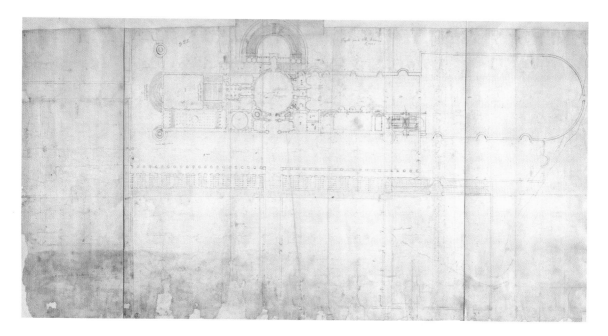

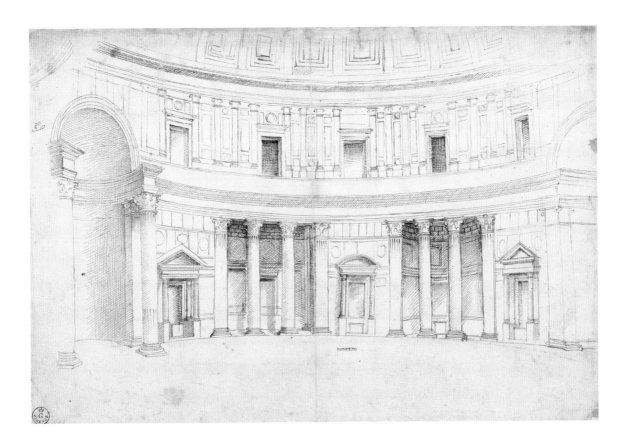

Sangallo and his assistants (p. 90), but just one to which Raphael may have contributed. The building was never finished. In 1527 it was looted by the troops of Charles V and afterwards lay neglected for a long time; it was later subject to several restorations and additions. For all that, it conveys even today an idea of the luxury villas enjoyed by Roman prelates of the High Renaissance. The idea was to recreate an antique villa with all its original components – separate living quarters for summer and winter, a theatre, a hippodrome, baths, a fish pond and terrace gardens. Complexes of this kind had not yet been excavated in Raphael's day, but were known from classical literature and in particular from the letters of Pliny the Younger, which contain descriptions of his two estates in the country. It is not surprising, therefore, that Raphael should also describe his project in the form of a letter, addressed probably to Castiglione. His text, which was evidently not accompanied by a plan drawing, was probably intended as a literary exercise (*ekphrasis*) and was annotated and passed on within humanist circles.

It is important to appreciate just how closely Raphael's literary and also archaeological interests in his latter years were bound up with his activities as an artist. This is also true of the proposal which Raphael, in a joint letter with Castiglione, outlined to Leo X barely a year before his death – namely to record in drawings all the surviving examples of classical architecture and where possible to restore them. With reference to the Arch of Constantine, the authors argue that although sculpture was in decline during that emperor's reign, architecture

Interior of the Pantheon, before 1508
Pen, 27.8 x 40.4 cm
Florence, Galleria degli Uffizi, Gabinetto dei Disegni e delle Stampe, n. 164 A

The present sketch is probably copied from an anonymous drawing book (the *Codex Escurialensis*) that Raphael is also known to have consulted on other occasions. The inscription "panteon" is written in Raphael's neat and delicate hand.

Secōdo

Fabio Calvo
Manuscript of Calvo's translation of Vitruvius
with annotations by Raphael
Munich, Bayerische Staatsbibliothek, cod. it. 37,
fol. 60 r.

Vitruvius suggests using fireproof larch in urban
Roman homes in order to prevent the spread of
fires. Raphael notes in the margin that this
should apply in particular in the narrow alleys
and the *insula* houses in the city centre.

PAGE 93 ABOVE:
Domenico da Varignana (?)
Raphael/Sangallo project for St Peter's of
1518/19: view and section, c. 1520
Pen and wash, 21 x 14.4 cm
New York, The Pierpont Morgan Library,
Codex Mellon, fol. 71 v./72 r.

Double page from a drawing book (*Codex Mel-
lon*) ascribed to the Bolognese sculptor and
architect Domenico da Varignana. None of the
ideas illustrated here came to practical fruition.

continued to uphold the principles laid down by Vitruvius. This meant that all
the buildings of ancient Rome could be treated as worthy of imitation. Raphael
consequently arranged for Vitruvius's theories to be translated into Italian and
worked on the manuscript himself (p. 92). The two things together, Vitruvius's
writings and the corpus of ancient monuments, would contain something like a
genetic code of "good architecture". The translation was completed but never
printed, and the recording of Roman remains probably never got past the earliest
stages. Of everything of which the world was robbed by Raphael's sudden death,
many contemporaries considered this to be greatest loss of all.

Pietro Ferrerio
Façade of Palazzo Branconio dell'Aquila
From: Pietro Ferrerio, *Palazzi di Roma de' più
celebri architetti*, Rome 1655

Giovanni Battista Branconio dell'Aquila was a
goldsmith from a family of high standing, who
made a career for himself at the court of Leo X
and was closely acquainted with Raphael. His
palace in the Borgo was built between 1518 and
1520; in 1661 it was torn down to make way for
Bernini's colonnade on St Peter's piazza.

FACCIATA DEL PALAZZO ET HABBITATIONE DI RAFAELE SANTIO DA VRBINO SV LA VIA DI BORGHONOVO FABRICATO
CON SVO DISEGNO L'ANNO MDXIIII
CIRCA E SEGVITO DA BRAMANTE DA VRBINO

Raphael 1483–1520
Chronology

Raphael's birthplace in Urbino

The house in which Giovanni Santi lived and worked is today home to a small collection of paintings, including a Madonna fresco attributed to the young Raphael, and is the seat of the Accademia di Raffaello, founded in 1872.

1483 Raffaelo, son of the painter Giovanni Santi and his wife Magia Ciarla, is born on 28 March or on 6 April in Urbino.

1491 His mother dies.

1494 His father dies. His uncle, Simone Ciarla, becomes his guardian. Begins his apprenticeship in the workshop of Pietro Vanucci (Il Perugino) in Perugia.

1500 Raphael is now a master. Over the next few years, he carries out commissions in Città di Castello (*Processional banner*, p. 15; altarpiece, p. 14) and Perugia (*Oddi altarpiece*, p. 16). Early Madonnas and portraits.

1502 Collaborates on Pinturicchio's fresco cycle in the Piccolomini Library in Siena cathedral.

c. 1504 Moves to Florence.

1505–1507 Commissions in Perugia: *The Ansidei Madonna* (p. 22), *Baglioni altarpiece* (p. 25) and fresco in the apsis of S. Severo; in Florence: *Madonna del Baldacchino* (p. 20), other Madonnas and portraits.

1508 Moves to Rome in the second half of the year. Starts work on the Stanza della Segnatura (pp. 38, 39, 40–41 and 42) under Julius II.

1509 On 4 October Raphael is given an office as a *scriptor brevium*, a papal scribe.

1510 First contact with Agostino Chigi (designs for two bronze vessels).

1511 Raphael paints *Galatea* (p. 68) in Chigi's Tiber villa. He starts on the Stanza d'Eliodoro (pp. 44, 45, 46–47 and 49).

1512/13 *Madonna di Foligno* (p. 60),

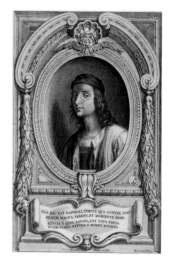

Jakob Frey
Raffael, 1710
Copperplate engraving after Carlo Maratti
Berlin, Archiv für Kunst & Geschichte Collection

The Sistine Madonna (p. 58), *The Prophet Isaiah* (p. 57), *Pope Julius II* (p. 80).

1513 Julius II dies on 21 February. On 11 March Leo X (Giovanni de' Medici) is elected pope.

1514 Raphael finishes the Stanza d'Eliodoro and paints *The Fire in the Borgo* (pp. 50–51) in the Stanza dell'Incendio; also *St Cecilia* (p. 61). On 1 April he is appointed architect of St Peter's.